Wedding Photography
A Guide to Posing

Part of the invest in knowledge series

www.oliver-cameron.com

OLIVERCAMERON
PUBLISHING

First Edition 2010

Oliver Cameron Publishing
Fourth Floor - Concorde House
10-12 London Road
Maidstone
Kent
ME16 8QA

www.oliver-cameron.com

Design by Martin Small of Smart in Design (www.smartindesign.co.uk).
Editing by Nick Primmer of The Write Stuff.
Consultation on selection of gallery images by Kerry Morgan.

ISBN 978-0-9565463-0-2

ACKNOWLEDGEMENTS

To the memory of my son Oliver Cameron Robert Pearce who taught me much in such a short space of time and continues to push and inspire me.

Dedicated to my mother Daphne for all she has done for me throughout her difficult life – I appreciate what you have done more than I have ever mentioned.

To the future with my wife Sarah and amazing son James – your dreams can become reality.

I would like to thank all the contributors to this book without whose help it would not have been possible. I not only invited friends who are some of the world's leading wedding photographers but also spent weeks searching for talent that was not yet globally known. I admire all of your talent.

I must thank in particular those who contributed chapters. Your inspired knowledge has made all the difference to this book. Also Andrena, Tammy and Mindy for all their help in LA.

During the course of my career a few people in particular have helped me who I would like to mention:-

DAVID WILLIAMS
An amazing educator, person, spirit and of course photographer. Thank you for your help, guidance and belief.

JOHN MICHAEL COOPER
My favourite photographer whose work, mind, imagination and art resonate brilliance.

JEFF CAPLAN
The founder of DWF, for founding it and helping me work through my fine wine collection.

JERRY GHIONIS AND YERVANT
Jerry and Yervants' work and business skills have inspired countless people including myself.

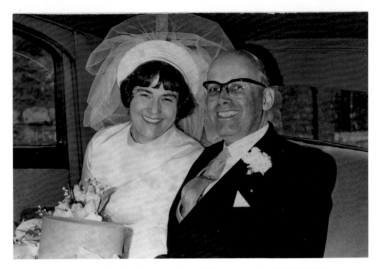

My Mum Daphne and Dad John on their wedding day on April 12th 1970.

My good friend David Williams recently wrote to me with the following thought: "Who do we actually photograph a wedding for? The participants? Not really. We record these events for those that weren't there or those yet to come. It is to leave something tangible for those the couple love."

I could not agree more. My Dad sadly died five years after this was taken, when I was three years old. His wedding photos are some of the only images I have of him. He was a passionate amateur photographer and we have boxes full of slides, including those from holidays – though as he was the photographer he is not in many of them.

This is a lesson for you in the importance of what we do, and in not forgetting to have your own family photographs taken.

HOW TO USE THIS BOOK

Posing people at a wedding is not a "photograph by numbers" formulaic scenario. Each couple is different physically and emotionally – it is our job to match the pose to the couple for the most outstanding results. It is only then that their true personalities shine through, as we slow down to think about the image we are creating and how best to achieve it.

This book is therefore not in the "cookie cutter" format. It is designed to provide you with the knowledge needed to create your own images based on the information you have learnt. I want you to think and see images, not just copy them. I would love you to train yourself to develop images in your mind's eye and then be able to translate them into beautiful photographs. This is not easy – it will need work, perseverance and tenacity on your part. Perhaps most importantly it will require you to practise.

This book has been designed to be read in its entirety. Throughout the 256 pages you will find facts, opinions and musings to help you. If you do not read the whole book you may well miss the most relevant and pertinent point to you. Its size allows you to fit it easily into your camera bag for reference. I suggest planning the shots you wish to take before the wedding and placing a Post It note on the relevant pages for quick retrieval.

We have priced this book intentionally low so you can deface it without being concerned about ruining an expensive volume. We encourage you to highlight with a highlighter pen all the facts and points that are of use to you. This will act as a fantastic aid if you quickly dip into the book (which we suggest you do) on the morning of a wedding.

Look carefully at the images and work out why they work and what makes them so good. It is only by learning this yourself that you will really see the full benefits. We have given you hundreds of tips and the key is for you to start looking for and noticing them. Try to visualise how you can transform the shot you are about to take by finessing it. What happens if you change the position of the body, hands, legs, head, or the expression or eye direction?

It is a huge responsibility to photograph someone's wedding and you are doing exactly the right thing to Invest in Knowledge to increase your natural abilities.

INTRODUCTION

Your purchase of this book was no doubt influenced by your desire to gain more knowledge and improve your photography posing skills at weddings. Like a great number of wedding photographers you probably run out of ideas, causing "blanks", and seem to create the same poses week in and week out. It may be that you have a good repertoire of poses but need to give your work the finesse and elegance you feel it is currently missing. This book's aim is to help you and provide you with inspiration to take you to the next level and beyond.

By sheer virtue of buying this book you have made a huge investment in your career and your ongoing improvement, at very small financial cost. This alone puts you ahead of most wedding photographers who are content to be static and work with the monotony of sameness every week. Some are even too arrogant to think they need a guide like this (I have met many in the making of this book). It is our responsibility to ensure the coverage we provide our wedding couples is to the best of our abilities. Like sportsmen we need to spend time training as frequently as time allows, to improve our skills. It is prudent to hire a model every few months to do this (you can get amateurs for free very easily, or ask friends). It would be ideal to get together a group of other photographers, enabling you to help each other. This alone will bring far greater rewards than the latest piece of equipment. If you are an amateur and covering a friend's wedding then explain to the bride and groom the importance of practice sessions – not only will they be more comfortable but you will be able to review your images and make necessary adjustments.

We have purposefully designed this book to be pocket-size, enabling you to take it with you to weddings. It can act as a prompt or allow you to quickly reference a certain point. It should not live in your camera bag though – it should be picked up and read as often as you can. You should certainly look through it the morning before each wedding to refresh your memory. The repetition will help you take in the knowledge contained within and eventually to use it instinctively. By remembering a certain point or pose you will be able to reference it when the time arises and you find yourself in a similar situation.

The book is inspirational and the images stunning, with beautiful people and locations. But it is balanced. We have taken care to include normal people in normal locations as this is what is normal for most photographers. You need to know how to get the best out of basic surroundings and make people who may not be comfortable being photographed feel at ease. Not only do we cover these issues but also some advanced topics such as adding finesse and elegance, fashion posing and, of course, off-camera lighting, which can transform your work. By learning these you can only improve, especially if you are not naturally artistic.

You will find contradictions within the text and images, as the book has been written by multiple authors. Photography is an art form and therefore subjective, so this is intentional. I want you to think about the different approaches and make up your own mind. This will help you to develop your individual style which is what every photographer should strive for. I personally dislike seeing the groom holding his bride with one arm whilst the other dangles by his side: why would he not want to hold his bride with both arms? For some though this is fine and indeed on occasion planned.

It is also worth noting that weddings are real live events and that we are just one cog in the wheel. Brides can run late and the food arrive early. We have to cope with these variables and not let them fluster us. Even with a good amount of time you will still have some pressure to contend with to get great images. Unlike other photographers we have a very short space of time to capture images that will be remembered and loved forever. It is easy to make mistakes and most photographers will do so at every wedding. How many times have you reviewed your images the next day and wished you had only moved the bride's hand or turned the groom slightly? Although we are seeking perfection it is very doubtful we will find it.

What we need to do is focus on improving at each wedding. Quite often this simply means slowing down and thinking in terms of quality and not quantity. You may find it helpful to pre-visualise the specific poses you wish to do at a wedding that will be complimentary to the bride and groom. These should always be in addition to the basic and safe poses. I strongly recommend that you focus initially on mastering the basic poses before progressing to the fine art portraiture.

This book will help you realize any errors you have made and help you to correct them at your next wedding. This will enable you to progress your abilities as a photographer and retain your passion for what you are doing. Your confidence will greatly increase and you will become more and more proud of your work. The only detriment is that the more you learn the more you realize how much more there is to learn.

I hope you enjoy reading the book. We have not made it too technical, preferring to teach you in a way you can relate to easily. This is very important as you need to practise what you have learnt. Make a promise to yourself that you will use this book often and not just the once.

THE INITIAL MEETING – SETTING EXPECTATIONS

It is likely that most couples will wish to meet you before booking, and it is at this stage you need to discuss what their expectations are and explain how you work. This is a large topic in itself so I will just focus here on the posing element of the wedding day.

Some people, if left to their own devices, will just flick through albums without even looking. Photography to them is like a commodity – they have to have it but are only really concerned with themselves and what they look like. Their choice of photographer may be based mainly on personality and on you being in the same price bracket as their friends spent. Or they may have carried out extensive research and already know the quality of your work. Ideally you will have spoken on the phone and filtered out customers who are simply price-shopping, favouring those who are interested in your art.

When the couple arrives (or you go to meet them) be upbeat and happy. Smile and be warm as though you are already friends, as first impressions really do count. You want them to feel relaxed and comfortable in your presence. Pay attention to what you are wearing: does it convey the image you think it should for your business and the surroundings you are in? Whilst you get refreshments it may be an ideal opportunity to play them a slideshow on a TV, projector or laptop.

Talk about their wedding enthusiastically, asking numerous questions. Try not to talk about yourself as they are really not that interested at this stage. Listen to what they say and take mental notes: what little things do they mention that you can bring up later? Do they mention any concerns? If so, wait and then address those in conversation later on. It shows that you have been listening to them and instils confidence.

To achieve the results you and your prospective clients want, you need to discuss what you need from them in terms of time. This will be dependent on you personally, and your style. The couple will not really know how long to allocate for their formal and group shots, so I find the best way to establish this is when looking through albums.

Talk couples through your albums. It is an idea for you to turn the pages and talk about the design and certain images in more depth. This will allow you to set the pace. When you get to any posed images, take time to explain them more carefully. Say why the bride is posed in that way: for example, so that you can see the line

of her dress and how the light is just perfect. Point out the connection between the couple and how you manage to capture that. Explain that to achieve similar results will take x amount of time. If you do not have this then they may not get results consistent with your sample albums.

I sometimes have a copy of Vogue on the table. I suggest to the couple that to achieve that single cover image would have taken a whole team and maybe 4 hours to shoot, so the longer we have to get a whole series of shots in multiple locations the better. How long we are given depends on how important the posed images are to the couple. By taking time to talk through each shot they should begin to understand that photography does take time to do properly. The more time allocated to you, the more shots you can take. If you do not ask for the time then you cannot really expect it on the day.

Set time expectations for the day, starting from when you arrive. It is quite normal for the make-up artist to overrun leaving no time for you to take bridal portraits and images of the bride with her parents. Discuss this with the bride before the wedding and ask her to ensure she is one of the first to be ready. Ideally she should be about to get into her wedding dress when you arrive. She will be more relaxed and you can concentrate on taking beautiful photographs.

Think about the time of the day and the light you can expect when taking the posed shots of the couple. Will there be strong overhead sunlight or will it be dusk? Can you change the time when you take the photographs, to achieve better light? In summer with a 2pm wedding I often do two sessions. The first is during the drinks reception, when I take the couple indoors, and complement this by some traditional shots outside in open shade. I may also take a series in direct sunlight and use it to my advantage. Later on, when the sun is lower in the sky, we will do another session outside of more contemporary poses. Of course it is down to the individual wedding, but you can discuss these possibilities with the couple beforehand and work out a plan of action.

With less traditional couples you can discuss the option of doing a selection of posed images together in the hours before the wedding. This is a perfect scenario and one that frees up the bride and groom to enjoy the cocktail hour in full. Virtually everyone who has done this has reported that it did not affect the moment the groom first saw his bride walking down the aisle.

The purpose of the initial meeting is to get the couple to book you for their wedding. It is my belief that if you talk them through the day, show them your previous work and explain what you need in order to create the quality of work they have seen in your samples, then it will not only instil confidence in your services but will also set realistic expectations.

DEVELOPING A CONNECTION TO IMPROVE YOUR IMAGES

A wedding is all about the emotion of the couple and the love they have for one another. We need to find a way to show this in our work, for our images to really shine. Some couples will naturally be very emotive and easy to work with, but the majority of the time we need to help them. I think it is fair to say that in some countries people are more reserved than others: they are not as outgoing or confident in having their photographs taken as others. Some will actually dread the formal part of the day due to their shyness or insecurities about how they look. We can help them overcome their anxieties, or capitalise on those who are naturally extrovert and perhaps even need to be reined in a little.

Developing a connection starts at the initial meeting before you have even been booked. Here you explain how you work (please see the "Initial Meeting" chapter) so they are familiar with your style. You may also have to look hard at yourself and how you project yourself to them. What is your personality type? It is worth remembering that people will book you not only on your work but also on how much they like you (although some will book over the phone without meeting). So the likelihood is that if you are extrovert then they may be as well, or they seek comfort in knowing that you will take control and give them direction during the formal photos. The most important thing when you meet is to treat them like a really good friend and not like a customer. They will instantly warm to you, but do not go overboard with this. It is all about balance. Try to imagine how you would feel meeting your bank manager if he was very serious and solemn, or what you would feel if instead he gave you a warm welcome and took a personal interest in you.

This book is not meant to delve into psychology, so I suggest you undertake further reading for more detailed information if you find it hard to interact with others. By virtue of you buying this book I would guess you are quite an outgoing person anyway, or are perhaps a more introverted photojournalist wishing to improve your posed work. In either case the following should help you.

How many times has someone said to you: "I hate my photograph being taken"? The reason is generally because they have only ever had images taken by their friends, using a wide angle or extreme close-up lens, on a compact camera with direct flash. It is no wonder they do not like images of themselves! By showing them how amazing they can look in photographs with you behind the camera you will naturally break down this belief.

It is worth the effort, if feasible, to do an engagement shoot with the couple. The benefits of this far outweigh the time spent working on it. I always try to combine

this with a scheduled meeting with the couple so they are at my location anyway. I prefer not to use the wedding venue, as the images may be duplicated. By having this session you can observe the couple. Are they "touchy-feely" or is it hard for them to express their love in public? Are they comfortable having their photo taken, or very nervous? Are they "blinkers" (constantly blinking so they have their eyes shut in the photos) or do they stare a lot? Do they look at you or at each other? By observing these details you can build a good knowledge of items to discuss with the bride and groom to improve their photos before the wedding. You can go over "live" what you are trying to achieve, by showing them the image on the back of the camera. Be careful not to criticize them in any way, as this could dent their confidence. Instead suggest ways to enhance what they are doing, take the shot again and show them the difference. It may be helpful to take some prints along with you to show the type of poses you are trying to achieve.

Start with the basics and let the couple ease into the shoot. Demonstrate how to stand and repeat the pose in a few locations. All the while have in your mind the type of shots you wish to create later on. You need to build up to these "wow" shots. Remember that this may be the first time they have been photographed professionally. Build their confidence all the time. You have to make them feel how you want them to look. The tone of your voice has a bearing on how the bride and groom respond to you. Use it to control the shot: perhaps be louder and more jovial to make them laugh and speak more softly to capture intimacy. Try this – it really does work. The amount of energy you create will have a direct impact on how they act.

I find that it can help if you can laugh and joke whilst shooting, to capture their emotion. It does not matter how silly you feel as long as you achieve a positive reaction. Whilst this in itself makes a great shot you will find that immediately afterwards they might give one another a loving glance, have a touch of heads or hold hands as a sign of reassurance and love for each other. This is the shot you really want. It is full of natural emotion and will complement the humorous one perfectly.

I suggest beginning each session standing relatively close to them so they can clearly see you. As they grow more comfortable, move back for any wide shots you wish to take. By this stage they will know what to do and will not stand like statues simply because they cannot hear your direction.

It is vitally important, if you wish to develop a strong connection leading to meaningful photographs, that you only use poses that are flattering to the couple. For example, if you have a "plus size" bride who is quite introverted then building up to a high fashion pose is probably not the right approach. You need to listen to the couple. If they look or feel silly then the resulting image is likely to show that. If they are naturally full of fun and humour then a sultry pose may not work. The idea is to bring out their natural personalities and connection.

Speak to the couple between locations. How do they feel? Are they relaxed and feeling confident? Can you involve them and ask them to come up with a pose or location? You need them to trust you and think of you as a friend. A very good way to achieve this is by asking them questions about themselves and taking a genuine interest in them. Everyone finds it easier to talk about themselves than having to think of something to say to you. Ask open-ended questions to which they cannot easily give a yes or no answer. Look at their body language too, which can tell you so much about how they are feeling. Are they hiding from you with crossed arms and looking defensive, or have they adopted an open posture, suggesting they are receptive to ideas and to what you want them to do? Remember to smile a lot as well and encourage them – tell them how great they are doing. If you look at the back of the camera and have taken a bad shot then be careful not to let them know, in case they assume it is their fault. Just say you would like to do it again for a slightly different look.

It is really important to edit very tightly before you show the couple the engagement shots. You want to ensure that they look great in every image to alleviate any insecurities they may have. Of course, some people will never like how they look so you can only do your best, try to understand what it is they don't like, and then address it. Talk through the images with them and reiterate what you said during the shoot, so they can see why you said it. It is all about confidence-building.

Having completed an engagement shoot, the couple will hopefully be really excited on their wedding day and be relaxed with you. All that hard work will have paid off! You should have taken the time to explain how to stand and hold themselves in an elegant and graceful manner, so they could practise it at home. This again will be of great benefit.

FINDING GOOD LIGHT

Quite simply, light is photography. Without light, photography would not exist, so it is imperative that we train ourselves to recognize good light and know how to find it. The most amazing pose will be rendered worthless if captured in bad light. When taking posed images there can be no excuses at all for not photographing in good light, as we are in control of the situation. It may be that the bride and groom wish to have a photograph taken in front of a particular building but the light is poor. In this instance it is our job as professionals to create good light via flash, video light or reflector. I have detailed below the various types of light you can use.

OVERHEAD DIRECT SUN

Working in direct sunlight can be problematic for the photographer. It is a harsh and generally unflattering light that can highlight any flaws in a person's skin. When overhead and high the powerful light renders shadows under people's eyes, noses and chins, unless posed very carefully. In addition, it makes exposure difficult if the bride is wearing a white dress and the groom a dark suit. By exposing for one you are more than likely either to blow the dress out or block up the blacks in the groom. When posing you are in control and can avoid this situation either by shooting in open shade or by working with the bride or the groom in the direct sun. You may also consider using fill flash, reflectors or a GOBO (a device that looks like a reflector but blocks out light).

If you choose to work in direct sun then you have to embrace it. Have your subject turn their face towards the sun in order to fill their face with light and avoid "raccoon eyes". They will no doubt have to tilt their head up towards the sun, but ensure they do not look directly into it. You might ask them to close their eyes until you are ready to shoot, and then instruct them to open them just before you press the shutter.

HAZY DAYS

The light on hazy days can be fantastic. It is soft, diffuse and flattering to the skin. Harsh shadows are non-existent and you can work almost anywhere. Be careful though still to find the good light. In addition to using the hand technique mentioned below, you can look for soft shadows which will indicate the direction of the sun. Sometimes these will be very faint, but look carefully at objects around you and you will find them. A post, a pillar or even holding a pen vertically on the ground will provide a good indication.

OPEN SHADE

When the sun is overhead and harsh you might look for open shade. This may be under a tree, near a wall or building, or anywhere that is well lit but not directly lit by the sun. The light will be a lot softer, which is flattering to the skin and creates a visually pleasing image by illuminating harsh shadows and leaving even and clean light. However, you will still have to find this clean light to create the best image possible. To do this you could

Shot in bad light

Turned 180° into open shade and good light

simply ask your subject to turn through 180°, then notice when their eyes are well lit and have catch-lights. Alternatively, you could extend your arm and hand in a vertical position and turn through 360° to spot the good light when it falls on your hand. You might also find surfaces in the open shade which are reflecting the sunlight, and which are always good to shoot in. This may create a widespread light or a more narrow stream that can be used very effectively.

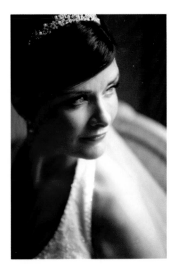

WINDOW LIGHT

A common mistake is to position a subject too close to a window and over-lighting them as a result. Take a step back from the window and use the palm of your hand to determine where the light is a little softer and clean. By moving further back into the room using this technique you will see your hand get darker as the light quality deteriorates. You may also need to move your hand up and down to find the sweet spot. This is something you can practise very easily at home. By using this technique you will avoid your images being too contrasty.

BACKLIGHT

Backlight can be used to stunning effect in your work and is one of my favourite types of light to seek out. Coming from behind your subject, it creates separation from the background and highlights the edges of their body, by creating a rim of light around them. As you are effectively shooting into the light source you will need to make some technical adjustments on your camera to achieve a good exposure. Your camera's meter will be fooled by having so much back light and as a result will underexpose your subjects (much like a silhouette). To correct this you need to tell the camera to let more light in. If shooting in manual mode, simply slow your shutter speed. If in AV mode, dial in exposure compensation to achieve the same effect. If you are unfamiliar with this technique then refer to your camera's manual, and practice!

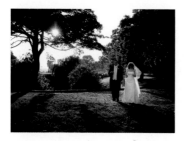

Lens flare can be a problem when shooting into a light source, and is accentuated if you have a filter on the front of your lens. To avoid this you can look for objects to hide behind to shoot, which will block out any direct line between you and the light source. Trees are good examples, or you could ask an assistant to hold up a reflector, or in fact anything that blocks the light from the lens.

DOWN LIGHT

Down lights are usually found inside venues along the walls. Often they are quite dim, making them difficult to work with, but the results can be quite effective. Have your subject stand near the light and simply look up into it, to fill their face and eyes with light.

FLUORESCENT

This is a horrible light that is usually green, and is best avoided as it is usually ceiling mounted. Black and white is a option to consider here.

TUNGSTEN

Tungsten light is very warm and found mainly in houses and in table lamps. Always turn these on when shooting in a room, to add warmth and light. Make sure the seam of the shade is at the back so that it does not appear in your image. One effective use of tungsten lighting is to light your subject with a tungsten source near a source of natural light. Turn your white balance to tungsten and the daylight will render itself blue, whilst your subjects retain the warmth of the light.

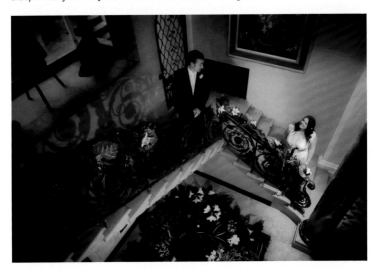

FILL FLASH

Fill flash should be exactly that: a fill light and not the main light. This is a common mistake made by inexperienced photographers. Take your usual exposure reading and have your flash set to TTL. Then decrease the flash's power by one stop, so it balances with the existing light. Do ensure that the flash is not pointing directly at the subjects, as this is not a flattering light. Instead, bounce it from a wall to create some directional light. For best usage, point the flash head in the direction of your main light source in order to enhance it.

THE BASICS OF POSING

Posing the bride and groom correctly during the formal shots is the foundation of your entire coverage of their wedding. It is the backbone of what we do and what they will look back on for decades to come. It is our job to make each image as flattering as possible whist bringing out the connection between them and their love for one another (this is discussed in a later chapter). As photographers we all want to achieve the "wow" shots, which is only natural – these show off our skills and are possibly what attracted the couple to us in the first place. But before we start on these we have to warm up (just like an athlete would before a race) and get the couple into the "zone" for the more creative images.

Weddings are fluid events and on occasion we may not have the time to capture all the images we have in our mind's eye. We will have to work quickly and under pressure to deliver the remarkable eye-catching shots that will be the central focus of the couple's album. It is therefore beneficial for you to focus on a selection of basic (yet vital) poses that you can do quickly and accurately at the beginning of each segment of the day. There is nothing worse than forgetting a necessary image and not, for example, having a lovely, elegant, full-length shot of the bride. I am sure that the bride's mum Mum would not be too happy either!

The beauty of learning and understanding how to pose someone correctly is that it can be used anywhere, from in front of a hedge to the most glamorous of locations, and the couple will look amazing. Once understood and practised you will be able to flow through your preferred selection of poses and hopefully then have time to be creative. It is strongly advised that you have an engagement or pre-wedding casual portrait session with the couple beforehand, so you can teach the basics which they can then become comfortable with through practice. If this is not possible, then do a quick lesson when you arrive and make sure you have discussed at your initial meeting how you accomplished certain shots (see "The Initial Meeting – Setting Expectations"), which will help considerably.

As always it is important to choose the correct lens for the subject in hand. When shooting basic poses then anything above 50mm should be fine. What you do not want to do is use a wide angle (unless incorporating a lot of architecture with the subject relatively small in the frame) as it will distort the image considerably. This is especially true if shooting in portrait orientation close to the subject, or if shooting landscape with the subject at the edge of the frame.

The aperture you choose may be dictated by the lighting conditions you are faced with, and your personal tastes. I prefer to shoot wide open at f1.8 or f2.8 for 80% of the day, including the posed formals. I choose to shoot in this manner for a number of reasons. I have never met a bride who wanted to see every flaw in her skin, so by

shooting wide open I achieve a natural softness in the image. If shooting relatively close to your subject you will also blur the background, removing any distractions. You do have to ensure that everyone's face is on the same plane as your camera and the same distance from you, or you risk the chance of leaving someone a little too soft or - worse still - out of focus.

On a slightly longer focal length, such as over 85mm, and shooting wide open, it may be that the depth of field is much less than 50mm and perhaps only extends to a few millimetres - so it is essential that you are confident doing this. When shooting wide open, close to your subject, with very limited depth of field, it is imperative that you use the focus point sensors and do not use the centre point and recompose. The very fact you are recomposing means that the camera's sensor will move position, changing the focus point in your image. Do not try this for the first time at a wedding: ensure you are 100% confident first.

It is important not to spend too long on each pose as the person will get stiff and tense. Remember to help people relax – keep talking to them and don't hide behind your gear. Get a great response from them just when you press the shutter, and your image will stand out for its naturalness. In most shots you are looking to capture the love and emotion the bride and groom have for each other. In a lot of your posed work you will want the bride and groom to be positioned correctly but acting naturally - enabling you to capture the natural connection between the two of them. On occasion an image will be very obviously posed, which is covered in the "Fine Art Portrait" chapter.

POSING THE BRIDE

Perhaps the single most important element is posing the bride in a way that will flatter her and make her look elegant whilst ensuring she is comfortable. This comprises many factors, with the most important being that the shot you take is in good light (see the "Finding Good Light" chapter) or you create good light to shoot in. This can be tricky, especially if she is wearing a white dress which you do not want to blow out. You need to pay attention to her foot and leg positions, which side her weight is placed, the position of the hips, the height of the shoulders, the direction and position of the head and finally the placement of her hands.

Once you have done this it is vital to observe the small details. Take a step back to look at the bride and evaluate the scene. You want to ensure that her tiara is straight and her dress looks beautiful. But do it quickly. Your eyes should be constantly scanning the scene and the subject for anything and everything. Take the time to fluff the dress to add body and shape. Position it so that it flows beautifully and naturally. Look beyond the bride into the room. Are there any distractions? You should be looking out for any bright objects that stand out or anything out of place, like a bag on the floor. Depending on your shot it is advisable to turn on any

supplementary lighting, such as table lamps, to add warmth and provide separation from the background. Take time to move the lamp shade around until the seam is at the back. Watch out also for items appearing to grow out of people's heads or strong verticals cutting through someone's face.

There is a lot to do but once practised it is very quick and becomes instinctive. Ideally, we always want the bride positioned so her face is front on to the light source, but her dress is side lit. That way her face is flattered and the dress shows detail. And once you have the bride in place and have ensured the background is perfect, make any small adjustments to the bride's pose in case she has moved. You will now want to give instruction to the bride to get the look you require. This will be totally dependent on what you wish to achieve. It is quite possible to get many looks in a very short space of time, as you can see from the examples below.

QUICK TIPS

1. Start with a shot of the bride smiling straight at the camera so you have the "safe" shot in the bag. Once captured ask the bride to look at someone standing to the side of you, take a shot and then get that person to make the bride smile.

Looking into an empty space

By looking at somebody an expression changes.

2. Not every image has to be of the bride smiling – take one with her showing her quiet elegance.
3. Ask the bride to look directly at the camera and smile with her eyes.
4. Be relaxed, make sure you are both enjoying it, and communicate with the bride – tell her how well she is doing and fill her with confidence.
5. Lean the bride forward slightly from the waist.
6. Ensure that you can see both shoulders. If you are shooting from the side and can only see one it will look very big.
7. If you are a little short like me then it is worthwhile trying to shoot from a slightly greater height than the bride. This means she will naturally look up towards you, extending her chin and causing the skin to tighten a little, thus reducing any double chins.

8. When shooting a ¾ view do not let the bride's nose "break through" her cheek. It should be contained within the cheek which will minimize the nose. You can ensure this shot is more flattering by seeing that her far ear disappears out of shot so you can see a small amount of face behind her far eye as well.

Nose breaking the cheek

Correctly placed nose

9. Ladies like to have full lips, and a little trick if they appear to be getting a little pursed is to ask her to gently give a pronounced kiss to the back of her hand. This will naturally puff the lips out as she extends her lips. Try this yourself and feel the difference.

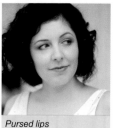
Pursed lips

Open lips

10. Look at the bride's eyes to ensure there are catchlights. Without these your portrait will look soulless.

Without catchlights

With catchlights

11. If a body part can bend then bend it.
12. Use your voice to control the shot. If you are looking for a soft emotional image then speak softly just before taking the shot. If you are looking to show laughter and passion speak in a stronger and louder tone. Try building up the volume you speak at, to enthuse and install energy into a shot if required.
13. By shooting from the shadow side of the bride's face you will naturally thin her. This is called Short or Narrow lighting. If you shoot from about 45° and the main light is coming from overhead it is known as Rembrandt Lighting.
14. Look for converging lines to draw the viewer into your image.

THE BASIC STANDING POSITION

As you know, how the bride stands is of immense importance to how elegant she looks and how flattering the photographs of her are. To achieve this do the following:

1. Having selected your location utilising the best light, stand in the position you wish to shoot from and ask the bride to stand facing you.
2. Ask her to turn her feet and body 45° away from the light source. You may wish to walk to that spot and simply ask her to turn and face you.
3. Return to where you will be shooting from and ask her to point her closest leg towards you, bend her knee, and push her hips away from you.
4. Now ask her to place her weight on her leg which is furthest away from you. She does this by moving her hips across just as if she is dancing (I sometimes demonstrate this to get a laugh). This also draws her body away from the light source and naturally thins her.
5. Looking back at you she will now have sloping shoulders, creating elegance and reducing her waist line by not being shot directly facing the camera. It also allows the light to travel across her dress, highlighting details.
6. She now has the correct torso and leg position for the shots, but we still need to pay attention to her hands, arms and head.
7. Her arms need to be away from the body so you can see light through the gap created. By doing this it naturally thins the arms. Shadow can do this as well. If the bride is empty-handed then suggest she brings one hand up to her corsage whilst the other rests in a soft position on her thigh. Do not let the bride hold the bouquet in both hands as this will thicken her upper arms very unflatteringly.
8. If she is holding a bouquet then this may be positioned by her hips or, if she is a larger lady, by her waist to aid a visually slimming effect.
9. The bride can tilt her head slightly towards her higher shoulder, creating elegance.
10. Ensure that the bride's shoulders are relaxed and not hunched.
11. Take the shot at full length, ¾ length and head and shoulders.

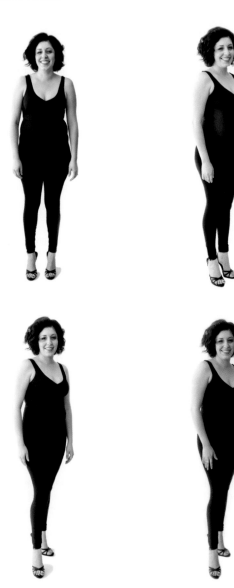

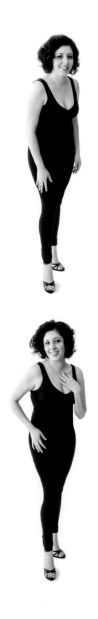
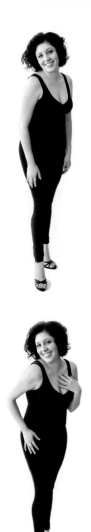

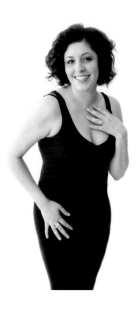

In the preceding pages we saw Mindy go through the various stages of creating the basic pose. From being front-on to the camera, to standing at an angle, with her weight placed on to her furthest leg and leaning slightly forward from the waist. From this position we have many options, such as taking a 3/4 length crop as shown to the right.

Try going in closer as well, and compose from the head to just below the bride's bust. You will have three images from one pose that offer you options when creating album pages. It is also worthwhile looking at a landscape composition to give you further scope in the design.

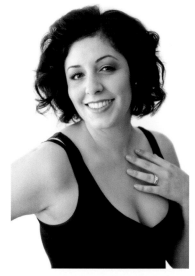

In this image we have used a dress as a backdrop, but you could just as easily use a curtain or tablecloth. This is useful if there are a lot of distractions in the background. The important consideration with every shot is light. Regardless of the tools available to us, it will always be about light and how we use it to shape our subjects, and our ability to bring out the life force in the people we record.

This was taken moments after the shot above. I got this tip from Jerry Ghionis, who suggested asking the bride to laugh and bring her hands to her face or something to that effect. It works incredibly well.

These are the same shots we saw on page 20 but included here to see if you also picked up on the other difference that containing the nose within the cheek makes. If you did not notice, it brings the far eye into the shot instead of cutting it off or just having the white of the eye showing.

THE BASIC SITTING POSITION

The bride should sit near the edge of the chair and lean forward with her weight going towards her back leg. I would suggest positioning yourself 45° from the chair to give a naturally flattering angle when she then faces you. I also like to shoot from above by standing on a chair, with a limited depth of field. You have to be careful that you achieve the correct angle otherwise the resulting image will look a little strange. By shooting wide open (f1.4, f2.8 etc) you will create a natural softness which lends beauty. Ensure you focus on the eye closest to you. To do this correctly you need to move the focus point in the camera. If you focus and then recompose, the CCD will have moved and consequently changed your focus point. This will happen with even a slight tilt of the camera, so always move the focus point to where you want it. You may like to invite larger brides to hold their bouquet as well, to incorporate that into the shot and also to act as a visual slimming aid.

POSING THE GROOM

Grooms can be a little awkward to pose as they may not enjoy having their photo taken, so you need to build up a rapport and get them onside. Most men like to stand in a particular way – when you walk into the room take notice of this as it is their natural stance. The problem is that as soon as they see you they are likely to stand up straight and adopt a very rigid pose, or evolve their stance into a "catalogue" pose. I often ask them to revert back to the same position they were in as I entered the room. Alternatively, I like to suggest the groom leans against a railing or wall, as I feel men need props more than ladies. Shoot this from an angle to achieve depth, and make use of leading lines. Get some banter going and maybe talk about their favourite movies. It is likely that they will be action thrillers so ask them to stand and look like the main character but without the menacing face.

The majority of the time you will want them to look masculine whilst being comfortable. The shoulders can be broad to emphasize this but be careful that they are not hunched. He does not want to look like a doorman! Whereas the bride may tilt her head to her highest shoulder, the groom can if you wish tilt his to the lower shoulder. If the groom is seated then ensure he sits "tall" and does not slump. This is particularly important if he is wearing a waistcoat.

The same principles you applied to the bride pertain to the groom as well: good light, not straight on and placement of the hands. You need to have a more masculine approach here with stronger hands.

POSING THE BRIDE AND GROOM TOGETHER

You need to decide if the image is of the bride and groom together or if the portrait really focuses on just one of them. Let's start with them together. It is far more

pleasing to the eye if the bride and groom are hip to hip and chest to chest instead of side by side. You should be trying to show the connection between them. One common occurrence and pet hate of mine is "Dangly Arm Syndrome". This is when the groom is holding his bride with one hand and the other is left dangling down or in his pocket. If I was a groom and had just married the lady of my dreams I would want to hold her with both arms, so please get them around her.

As two people are now involved they should not be quite so static. By all means ask them to touch heads, look at the camera and smile, but then encourage them to communicate with each other. Ask him to gently touch her cheek, for her to vary her arm positions around him from the waist to the neck. Make a joke to make them laugh, all the time looking at each other. Ask the groom to hold her hand and look at the wedding ring, paying attention to how he holds the hand. It should be with elegance (see below). By conversing with them and even making a fool of yourself it should encourage them to look at one another in a loving and cheeky way. You will be able to see this in their eyes. This fleeting look will often happen for a brief moment after they have fooled around – be aware of this and do not stop looking for the shot. By shooting in this manner you can change the location regularly and get a series of different looks and expressions. Try moving forward or zooming in for a ¾ length or head shot.

If you encourage them to touch heads, then make them almost touching or just resting a hair's breadth apart. Look at where one person's nose is in relation to the other's eye. You do not want to cut across it. The same applies to kissing: a full-on kiss is not pleasant to look at and leaves little to the imagination. We want to invoke an air of suspense in the image so have them barely touching lips or leave a very small gap. You can really shoot tightly on this shot as well.

Think about the way they are posed. If you are taking a shot where they are side by side or one is at an angle, ask them to place their weight on their inside foot. This will bring their shoulders in together, creating a V shape which is visually pleasing.

Remember to pay attention to the small details such as the dress and distractions in the background.

You can also photograph the bride and groom in the same shot but separated. Simply pose them individually to do this and then ascertain where they should be looking. You may choose to have the bride looking at you and the groom at the bride, or looking at one another, or both looking at the camera. Evaluate your composition and see if you can create a diagonal between their eye lines. You can also keep one sharp and throw the other out of focus, but this will be covered in the "Contemporary Posing" chapter.

POSING LARGER PEOPLE IN A FLATTERING MANNER

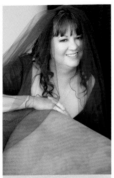

Posed behind a chair

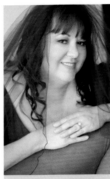

And with a tighter crop

Every bride and groom wants to look amazing in their wedding photos so we should be able to work with people of all body types and sizes. We need to use our skills to ensure they appear at their best. There are a number of techniques we can implement to achieve this with larger people. You can position the bride as above which will give her more shape. Try blocking some of the subject's body with furniture.

For example, ask the bride or groom to stand behind a chair and gently place their hand on the top. If one person is smaller than the other then pose them in front. It is very important to ensure that the arms are away from the body so light can shine through. Pay close attention to the lighting as this can really work in your favour. If you can create shadows along the length of the arms this has a great natural thinning effect. Try not to pose larger people sitting down, especially men with waistcoats and brides with a corset, as these will push up and be very unflattering. If you do have to sit them then place them on the edge of the seat and leaning forward, for a more flattering image.

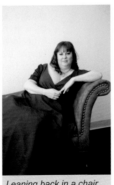

Leaning back in a chair

Sitting forward in the chair

Alternatively, have the bride sit down and shoot a tight crop from above with your lens wide open to diffuse her dress.

This image was taken straight on and at eye level. It is not the most flattering of angles.

By changing your position to shoot from above you create a far more flattering image. Tammy is looking up at the camera which gives a more defined chin. Her shoulders are down and a little forward and she has placed her tongue on the roof of her mouth (not to her teeth) which enhances her smile. This was a great tip that Tammy gave me herself and it really works. These small changes vastly improve the shot, as you can see.

If you are photographing a larger-sized bride with a veil, use it as a slimming aid. By having it fall down the side of the face you draw attention away from the cheek and onto the focal points of the face.

This also works very well when shot close up. By asking the bride to hold the veil softly in her hands you can wrap it around her whole face.

If long enough the veil can also be used to cover arms.

This style of shot is very easy to do in an unflattering way. It is the little nuances that make all the difference. In the top image I have shot from in front of Tammy with her head resting on the arm of the sofa. This has caused her cheek to be pushed up and enlarged. It is not very elegant. By moving around as in the bottom image and shooting along her body at 45° we see a great improvement. The cheek is now elegant and perfectly formed. We also have no creases in the neck. You often see shots similar to this but with wrinkles on the forehead. This is caused by the head being in the wrong position. It needs to be placed back to really stretch the neck. The eyes should not be rolled back towards you as this pushes the forehead up.

If the bride has a strapless dress then you need to pay attention to the area between her chest and upper arm near her armpit. This can be unsightly so Tammy suggests you ask the bride to extend her arms out with her palms facing the sky. Then ask her to drop them naturally to her side and finally bring them forward slightly.

I find that if a larger person is a little insecure about their weight it can help to bias your coverage towards creating and capturing their emotion. The first thing anyone looks at in a photograph is the face. Therefore if you can capture great expressions, or shoot tight from the shadow side, this will be the focal point. It will detract from the torso and be more pleasing for the person.

POSING COUPLES OF DIFFERING HEIGHTS

Occasionally you will have a situation where either the bride or the groom is significantly taller than the other. This is not a problem. They will be quite aware of their height difference and it will not bother them at all. You will still want to take flattering photos though, so try to eliminate the difference in a few shots. You might ask the taller person to sit down whilst the shorter person stands next to them, and then bring their heads closer together. The shorter person may also sit down - perhaps on the taller person's lap or, if shooting on stairs, then one step up. Couples of differing heights will give you the opportunity to create a strong diagonal line between their eyes which can be very powerful. See how you can use it to your advantage. I have included a number of examples below to provide some inspiration.

FAMILY AND GROUPS

A lot of photographers dislike taking group or family shots as the process can be seen as long-winded, time-consuming and boring, and can take some effort to organize everyone involved. Couple that with the bride and groom's relations behind you trying to get their shot, and it is easy to see their point.

To address this situation I believe you should embrace the family shots and see them for what they are: a record of certain people at a certain event at a certain time, that will be treasured in future generations as a family heirloom. It is vitally important to get these shots right and treat them as one of the most important parts of the day. If you have ever looked back into your family history, it is often in wedding photographs that you see your relations and can determine who they are. By taking these shots now you could be helping someone in 300 years' time to trace their lineage.

Preparing for the group shots starts at the pre-wedding consultation (having already set expectations in your very first meeting), where you will discuss required groupings and timings with the bride and groom. I always stress the importance of these, whilst at the same time explaining that they can take time to be done properly. It is relatively quick to position people but it is getting them all together that can be the problem, as an Auntie might be in the bar whilst a brother is in the toilet. I find it helps to have a written formal list (although this will invariably get added to on the day) which is distributed to everyone required, with a rough time that they need to be ready. I suggest allowing 4 minutes per group to enable me to achieve the same results they have seen in my sample albums. This will focus their minds and hopefully ensure that there are not multiple permutations of people. As a rule I would include the following:-

Bride & Groom + Bride's parents
B&G + Groom's parents
B&G + Both sets of parents
B&G + Both sets of parents and grandparents
B&G + Bride's parents, siblings, grandparents and aunties and uncles
B&G + Groom's parents, siblings, grandparents and aunties and uncles
B&G + Bridesmaids
B&G + Groomsmen
B&G + Bridesmaids and Groomsmen

I do not specify a location as this can vary. Although it very pleasant to have the group shots outside, if the weather is bad, the wind strong or the sun high in the sky causing unflattering shadows, I will look for a good location inside. Here I can control the light and have more furniture to use to position people. I will generally

ask the ushers to ensure that everyone is ready so that I simply have to call them in when needed. I also make sure that the catering staff do not forget to offer canapés to the bride and groom, as I find this helps to keep them going.

When choosing the location, I am acutely aware of the background and of ensuring there are no distractions such as trees potentially growing out of people's heads, stacked chairs, used glasses or drainpipes. If I have the room available I will bring the grouping away from any walls, hedges or sides of buildings. I want to create depth where possible. The light will influence your decision greatly – you need to ensure that you are in even light to avoid a dappled effect spreading across people faces. Ensure that the sun is not too much to the side causing one side of the face to be in harsh shadow and the other in extreme brightness, creating strong contrast. Where possible I like to shoot in open shade, or backlight the groups giving a beautiful rim light. Be careful though not to work on the extreme wide end of your lens, as you will distort the people at the frame edge. Sometimes it is not possible, but always try to shoot at 50mm or longer for a more flattering look. Remember to stop down as well, to f5.6-f11, to ensure good depth of field.

When composing the group I try to avoid what I refer to as the "Firing Squad" image of everyone in a line directly facing the camera. It simply does not look good. We have an opportunity to be creative so should use it. The first thing I do is give a very quick demonstration of how to stand in a flattering way, as explained in the "Posing Basics" chapter. This loosens everyone up and creates a good foundation. On occasion you will be under pressure and need to get through a lot of group shots in a short space of time. If this is the case then shoot basic groupings, but nicely. Line people up either side of the bride and groom (this works best with groups of up to 12 people) as you see fit. You may ask the men to stand on one side and ladies on the other, or boy then girl, or ask any couples to stand together. Ask them to move in close and stand in a flattering way. You will probably find that everyone is positioned facing in towards the bride or groom. Go in and mix it up. Have someone face the other way but ensure they are near to the bride or groom to avoid looking into the wilderness. If you have couples, then maybe have them facing towards each other or have the man rest his hand on the lady's shoulder. This breaks up the symmetry and makes the image more dynamic.

If you have a little more time, then see how you can make small groups within the big group. Try to make groupings of, say, 3 people together (never an even number as this does not work as well visually) and don't be afraid to have each group stand away from the bride and groom. They do not have to be together at all. In fact it is far more interesting if they are not.

If you have time on your side then you can really make the group shots special. I find that this style really works well with the bridesmaids and groomsmen, as they will "get it" more than older generations. As you have been at the venue for a while now

you will have had time to scout out some fantastic locations in which to take this style of shot. You are looking for architecture or strong lines. You want to be able to position everyone in a different place for the shot. If you can seat someone then this will also add to the overall composition. This is best illustrated by looking at the examples on the following pages.

Working inside is very similar but gives you more scope to be creative with every shot. Instead of lining everyone up, pull together a couple of chairs for the bride and groom to sit on. These will be your anchor from which to bring everyone else in. Have taller people sit on the arm of the chair and others stand behind (in a flattering manner). If parents are behind then they might place a hand on the bride's or groom's shoulder. If it is a large group then bring in more chairs if needed. This style of family portrait looks very classy indeed. Of course, being inside, you may need to use additional lighting. This can be accomplished by Wireless TTL flash, as discussed in the "Finding Good Light" chapter. Alternatively, a very quick technique taught to me by Peter Prior (www.peterprior.com) is to bounce your hot shoe-mounted flash back into a reflector which someone holds up for you. This will throw additional soft light onto your groups, giving a very elegant look.

I will always try to get a group shot of the bridesmaids at the preparation location, and then groomsmen at the church or venue before the ceremony. You may have a little time then so use it to your advantage. Once I have a shot of each group I will invite just the bride and maid of honour, or groom and best man, for some extra images. Here I like to take a mixture of images and may use a very shallow depth of field, only retaining one of them in focus. This draws the eye to that person and then I swap over to include the other. If time permits I will use it to carry on shooting at any inviting locations. These shots are a little less formal before the wedding, with the subjects standing in a relaxed manner as they might do naturally.

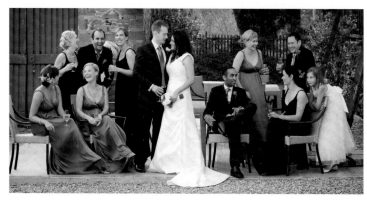

iMAGINE

Unique Images

Steve Zdawczynski

Romeo Alberti

Kris McElligott

37

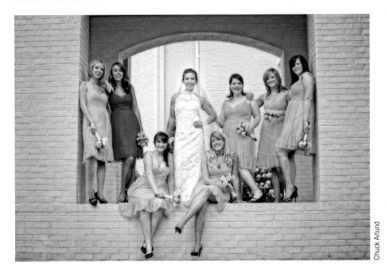

Chuck Arlund

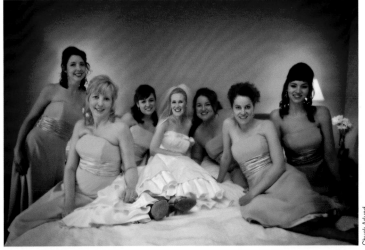

Chuck Arlund

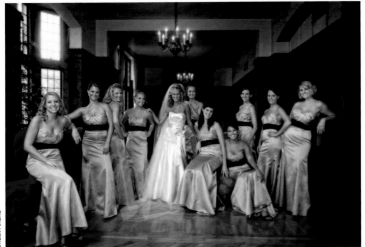

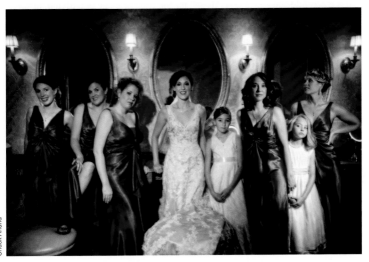

SHADOW AND REFLECTIONS

David Beckstead is one of the finest wedding photographers in the world. He constantly encourages us to search for amazing images, to stretch beyond our comfort zone and see images we have not seen before. He has kindly agreed that we can re-publish the following two chapters that he has written. His website and workshops dates can be viewed at www.davidbeckstead.com.

Often, at the very beginning of a wedding, photographers get pulled into isolating their clients, filling the frame with people, reacting to emotion, thus telling human stories with their cameras. All the while reflective surfaces abound and shadows beckon to be used creatively.

One of the key concepts is to take in all the compositional elements like natural light, lines, negative space, and two of the more abstract elements: shadows and reflections. A photographer should stand back and survey these elements first, take in how they relate to the subjects, how they interact with the subjects, and how this interaction can create magic within the photographic frame.

Sometimes all the pieces are there (like a puzzle) and it takes a pro photographer to put it all together in a powerful composition. In fact, most of the time these pieces don't just come together; you have to make it happen. I would also like to say that a powerful frame is "always there" for the photographer to flush out, or piece together, even in the most normal or boring circumstances.

Two of my favourite and more abstract compositional elements are shadows and reflections. Abstract because they represent real objects but are not objects themselves. Abstract because they are intangible yet can easily be photographed. Abstract because they are there, right in front of you, all around you, yet elusive and not always easy to see.

What I find by adding shadows and reflections to my compositions is that they bring with them a bit of interesting complexity. They enhance a simple composition by giving the viewer more interesting areas to look at, thus giving them a palette to study. By adding shadows and reflections, you generally are forced to pull back and see how these elements interact with the subject. Will they add more visual chaos that interrupts the story of the subject or will they add more powerful side elements that enhance the subject within the frame? Often, I go for a very quick "safe" shot and document the story or emotion of my client in a given circumstance. I then pull back and experiment with adding elements that tell a creative story of my own.

I see composition first, and secondly figure out how my subject "fits" into the puzzle. This is kind of a reversal of how it was and still is done.

Shadows, often being ephemeral, lend a wonderful abstract concept to an image. We know as viewers that shadows can come and go or change quickly depending on the movement of the light source. We enjoy the idea that the camera can freeze in time something that is fleeting. I find some of my best lead-in lines come from shadows. Reflections create a deeper, almost mystical space within the photographic frame that often enhances the appearance of depth. Depending on the type of surface that causes the reflection, the look can be a perfect replica or an impressionistic version of the subject. I like my reflections to be a little more imperfect so as to give me a more abstract impression.

Instead of trying to describe these abstract elements in words, let's dig right in and use my favourite form of communication: the photograph.

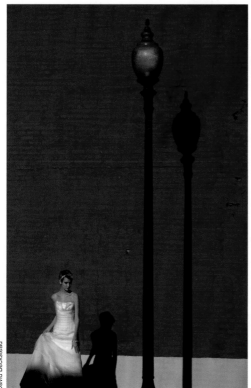

I originally saw the shadow of the light pole and had an epiphany: my model was long and slender, just what I needed to cast a great shadow right next to the pole and its own shadow. I cropped the bottom out to "float" the model and light pole into the wall, eliminating some perceived depth for an effect.

David Beckstead

41

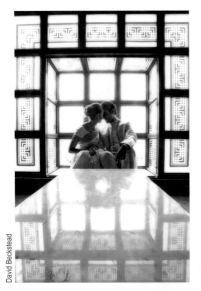

David Beckstead

I loved the lines of this alcove! I had made a walk-through before the reception to find places to try some artistic stuff on the bride and groom. I also noticed the glass tabletop. I had all the ingredients for a shot that would blow them away. And it did! They told everyone about the shot, and made me show them on the LCD again and again. You've got to love that! I accomplished the reflection shot by placing my 16-35mm lens right on the glass at the edge of the table so I could look through the viewfinder.

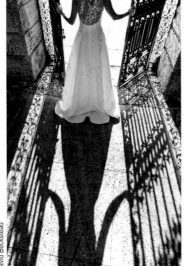

David Beckstead

This image is all about shadows, shapes and lines. The image would have worked well without the bride, but I felt the addition of the bride took the composition up a notch.

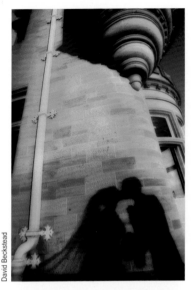

David Beckstead

I took a shot like this, years before, and tried to find a way to make it better. Not an easy process and I had attempted it many times since. I just wasn't satisfied with my results. Yet this time all the elements came into place. The shadow worked out perfectly! I set them up and they just kissed as long as I asked them too. They had fun!

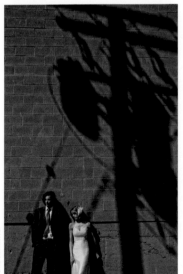

David Beckstead

I saw this electric pole shadow an hour before I could get to it and try a shot. Glad the sun helped by pivoting the right way. I still had my shadow and it gave me a chance to experiment with some abstract concepts.

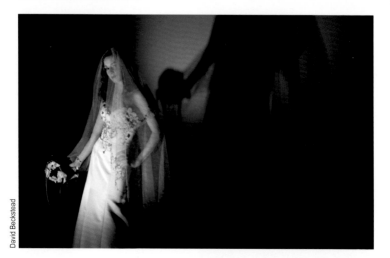

David Beckstead

I cast my own shadow with a video light. By placing the light at different distances from the subject, you get taller or smaller shadows with crisper or softer edges depending on what works for you at the time.

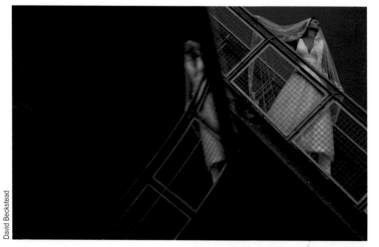

David Beckstead

I used a simple car window, from a car that was just there, when I needed to add a little complexity.

I knew I had to have these shadows and light. We had to wait forever to get the model across a busy road where I saw this scene. I placed her there and the cars blocked my view when I got back across the road. I got a few good shots off before the light quickly went away taking my shadows with it.

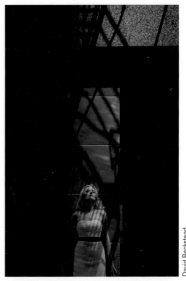

David Beckstead

Shooting the wonderful light on the model I turned to see what was behind me and was amazed by the reflection and depth of the store shop window. I created an abstract I am very proud of.

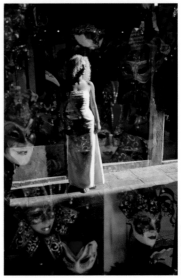

David Beckstead

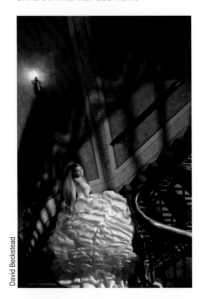

David Beckstead

I used a video light to cast shadows through the railing.

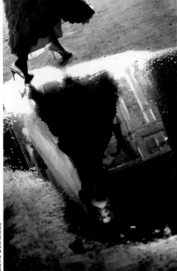

David Beckstead

The puddle made a perfect reflective surface. It was dark in this abandoned industrial complex. I used video light to highlight her face.

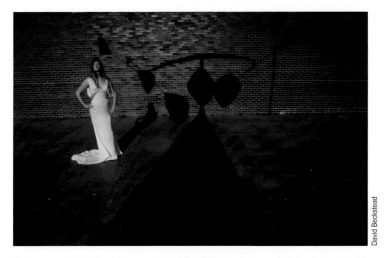

David Beckstead

A photographer told me it was a cliché to photograph these metal art pieces with brides because it is done all too often at this location. I vowed to try it a different way. So instead of photographing the actual piece with the bride, I just used the shadow. The photographer agreed that I done something they had not seen yet.

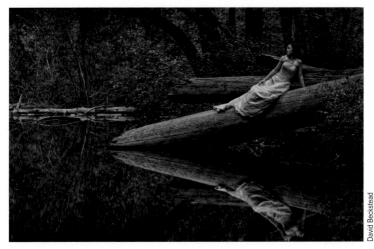

David Beckstead

The reflection gave me a chance to extend the wonderful tree lines. Very cool!

QUICK REVIEW

- Look for these elements in all your daily activities, even when you don't have a camera in hand.
- Stand back and view the whole scene before deciding how you are going to photograph people.
- Make compositional elements more important in your search to create great people photography.
- Pre-plan the use of compositional elements before the event. Find reflective surfaces you can use. Know that often the same shadows will be there the next day if the sun is out.
- Write out a list of elements you need to look out for and carry that list with you to events.

Prepare for mistakes and imagery that does not turn out like you thought it would. It is not easy to make compelling imagery using abstract elements. If it were easy, everyone would do it perfectly and dilute the uniqueness of the concept.

COMPLEXITY IN COMPOSITION

by David Beckstead.

With all the activities of a wedding day, it is so easy to get caught up shooting situations you have always shot: focusing a narrow vision on what the bride is doing, becoming caught up in getting the safe-shot, and backing up your safe-shot with more safe-shots because you have not yet developed confidence to branch out and try new imagery. A real enemy to creativity is the all-encompassing dread of missing a safe-shot. I will tell you this: I miss safe-shots at every wedding. I have learned to not worry about it. I know that my overall wedding shoot will thrill the bride and groom and a few missed safe-shots will not be in their minds while looking at the proofs, because what I have gained by experimentation overpowers a few missed shots. Instead, why not learn to believe your LCD and recognize the safe-shot is in the bag so you can give yourself time to play? You may only have one minute or less to try a different angle, look for an unusual composition, or just have fun shooting images for yourself. You may have more time to really study a situation and attack a scene with passion, thus creating more art by increasing the complexity or narrowing down your compositional elements for more elegant simplicity. This playtime is your playground for enhancing your perception.

Now with any room there may be a limited amount of natural light. How do you see what is there very quickly and utilise it to the best of your capabilities? I have a method that works: walk into the room, squint your eyes so all the complexity of the room fades away to nothing but darks and lights. Open your eyes wide and go to the light. Stand next to the light or in it, and then look for your intended subjects. Now first, see if this natural light can be used as a line, a pointer, or a guide to your subjects for a creative image. Then back off and perceive how the light can be used in an overall composition. Now that you have the natural light in a room dialled-in, get your first safe-shot (often using the natural light) and utilise your time between safe-shots to be artistic.

Understanding Negative Space is the ultimate in being perceptive. Lines outside run more often vertically. Trees and architecture often have many more vertical lines than horizontal in the outdoors. Trees create lines to help guide you to your subjects more easily through the viewfinder. Good Negative Space enhances the subjects or leads your eye to the subjects. Bad Negative Space leads you away from your subjects or detracts from the overall composition. So shooting good Negative Space in a horizontal format outside is not easy. There are so many elements that intrude on your search for good Negative Space to enhance your subjects. Dead space it just one more perceptive ability you should have in your arsenal of artistic ideas to try out at every wedding.

Seeing what is in front and to the back of the subject is very important. Knowing

how the background / foreground will affect the look of the subject in a composition is very important. The shades of dark and light, lines, and the complexity of the background / foreground elements can make or break an image. Colour can add depth. It also can detract from the subject. Black and white can flatten depth, but can enhance the subject, making it easier for you to focus on the emotional elements of the subject story. I believe each image should be viewed for these concepts of depth in post-processing before committing to black and white. To make things more complicated, colour can enhance the subject and converting to black and white may totally lose your subject in a sea of pattern and light. Perception during post-processing is also very important and can be learned with practice.

Lines are amazing pointers. They add depth to an image. They will help your eye follow through to your subject and add interest when looking at a print. Well, of course, you can fill the frame with just your subject, but wouldn't it be so very boring if all your shots did this? The wedding day is your canvas to paint; why not use all those brushes, paints and tools you spent good money on, to create your own stylised form of art? Here is a fun way of finding lines: fill the frame with your subject, now step back or zoom out and search for lines through the viewfinder that lead in to the subject. Look all around including the ground. This helps narrow the field of view, yet helps isolate a line or two that can aid your composition.

If you are lucky enough to find a ton of converging lines, change your angle or put the subject in the centre of all those converging lines, then shift your viewfinder to bring the subject into the centre. Now all the lines point to the centre of the composition and to your subject, for a dramatic image. I find it fun to look for this, but hard to make it all happen successfully: which is exactly why I try! If the lines will not come to you, go to them - use them to search out your subject with your viewfinder.

It is often good to see your wedding world with 16mm and 200mm eyes. I find it better to start each wedding location within the wedding day seeing in 16mm (the whole story and field of view). Then narrow your imagery down to 200mm to isolate subjects and pull in emotion. The range of millimetres between is fine, yet I find going a little more extreme with my focal lengths can create very dynamic imagery.

The normal human visual field extends to approximately 60° nasally (toward the nose, or inward) in each eye, to 100° temporally (away from the nose, or outwards), and approximately 60° above and 75° below the horizontal meridian. Yet are you really understanding all you see within that broad field of vision? Of course not. You have to focus on a smaller area within that field of view, and then concentrate on that smaller area or subject. There is no way to really take it all in at once and understand all you see. Photographic composition is the arrangement of visual elements within a frame. It is the product of a photographer's vision and skill in seeing, identifying, arranging, and framing the finished image. What we "see" is often visually chaotic. Our jobs as pros is to harness this chaos!

I define Visual Chaos like this: it is the intersecting natural and architectural lines that form all around the subject. The placement of the subject or the angle of the photographer dictates the balance or imbalance of the composition with regard to the Visual Chaos. Balance is best.

Eliminating all the chaos is not necessarily the best goal. Giving the viewer some complexity to explore often holds their attention. Simplifying the composition to one or two compositional elements, ridding the frame of all chaos, can make for a strong image or also make for an image that will not hold the viewer's attention. We will explore this visually in this chapter.

The depth of complexity and chaos can easily and quickly lose your subject. "Seeing" how Visual Chaos interacts with your subject and then harnessing this chaos in a powerful image is a skill that takes time to master.

My favourite phrase to use while teaching the concept of Visual Chaos is: "make the subject 'pop' from the background." How do we balance the subject with the Visual Chaos? Let's explore how to "pop" with imagery.

The subject can "pop" in these ways:
- Negative space: placement and angle
- Highlighting
- Tonal range
- Colour depth
- Photoshop

NEGATIVE SPACE AND SUBJECT PLACEMENT

One of the strongest concepts in framing subjects within Visual Chaos is Negative Space. I define my own idea of Negative Space as areas with fewer lines or no lines, areas of similar or single colouring or tonality and similar tonal textures and patterns. A wall painted one colour or a beautiful blue sky with no clouds are obvious sections of Negative Space. The challenge is to find Negative Space that is less obvious and utilising it to help separate the subject from the chaos. Negative Spaces are some of the best locations to place your subjects. Often I will walk into an area and search out areas of Negative Space to place my subject. I rarely pose a subject before I have found strong compositional components, such as Negative Space. This keeps from wasting the bride's or model's time and helps keep your awareness level up. Instead of just reacting you can compose. Instead of complaining of less interesting areas you make it happen.

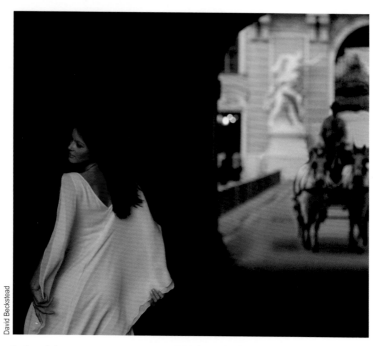

David Beckstead

I placed the model within a darker area of Negative Space. She would have been lost in the lines and chaos if I had placed her on the right hand side of the image frame.

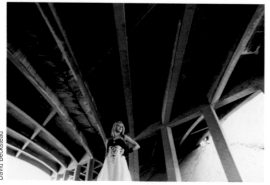

David Beckstead

I was sitting on the street when I asked my model to walk towards me so her head would be in the dark Negative Space.

There was so much visual chaos here! I placed her in the dark area so she could be a separate part of my different composition.

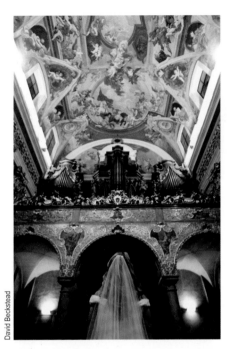

David Beckstead

NEGATIVE SPACE AND CHANGING YOUR ANGLE

More difficult yet very rewarding is to place your subject into the Negative Space by changing your angle of view. Documenting without interaction, yet artistically framing the subject in an area of less chaos, thus making it visually easier for the viewer to find, understand and interpret the photographer's composition, makes for powerful images. During a wedding I will document (rather than pose) 80% of a ten hour shoot. That is eight hours of continually looking for angles to find background Negative Spaces that help define my subjects. That takes a ton of focus on my part!

David Beckstead

Shooting up in the sandstone mountains close to Las Vegas, I asked the model to go up and stand on the rocks. When she got there I noticed right off that the chaos behind her was swallowing her up visually. I decided to try a little experiment in harnessing Visual Chaos. I had other photographers with me and told them to come with me but did not tell them why. We walked 100 yards and the model started to "pop" from the background as our angle aligned the dark area behind her. I could hear a lot of "oohs" and "ahas" which made me happy. My experiment worked!

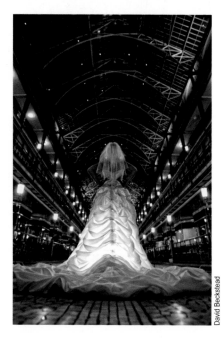

David Beckstead

On this next shot I found this crazy interior to be amazingly visually chaotic. By using a pair of video lights (one inside the dress) I was able to pop her from the chaotic lines.

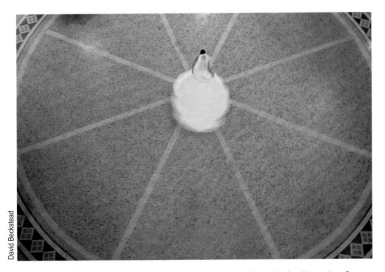

David Beckstead

I then decided to change the whole concept and really look for Negative Space, which seemed impossible within this interior. Changing my angle and going four storeys up gave me what I was looking for. I used a 70-200mm lens to isolate and eliminate most of the chaos.

HIGHLIGHTING

Natural light highlighting the subject from either the side, back or front can "pop" the subject from the background chaos. Flash and other forms of incandescent lighting can help separate the subject from the chaotic background. Using a source of light essentially bumps the tonality of the subject up against the tonality of the background. Reflectors are great for this! Lately I have been using a video light to improve the tonality of the subject. Often I find the most dramatic highlighting comes from natural sidelight with a darker background. This often happens when the sun shines through or around objects and gets blocked by other objects. This provides a perfect darker, even, tonal Negative Space to place your subject against, with sidelight hitting directly on them. It creates the kind of "wow" separation of subject and background I am looking for.

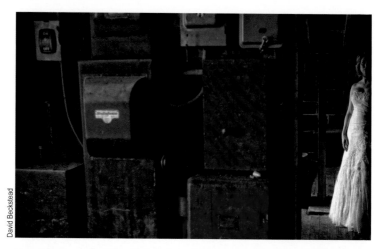

David Beckstead

Very chaotic and fun! The sidelight from the window gave me the "pop" I needed to help the viewer find my model.

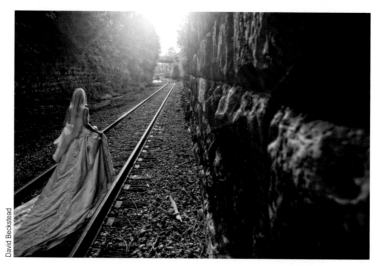

David Beckstead

Backlighting gave me the separation between the background and the bride.

Again the backlighting helped "pop" the couple from the background.

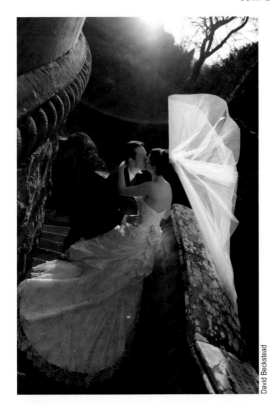

David Beckstead

TONAL RANGE

When I teach at a model shoot, I use the words "tonal range" all day. When the tones and colours of the model's skin, hair or dress blend in with the background in some way, I stand back and look for a new angle or position to place the model. When models blend into the background they get lost to the viewer in the finished image. Head and hair are most important to me when it comes to making sure the tonal range is different between the model and the background. Sometimes just adding a light veil to a model with dark hair against a background that is dark does the trick. Body and dress come closely after that in importance. Really if I am posing the model, tonal range from head to toe should be just right, yet when I am documenting an event, I will take what I can get. Changing my angle with regards to subject / background relationship can make all the difference.

Going black and white helped dull down the chaos of colour so the tonality of her hair and body could separate from the background.

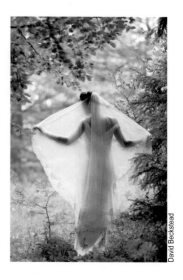

David Beckstead

She was looking down and the shadows on her face matched the tonality of the dark line behind her. I asked her to move her face to the light so the tonality would change.

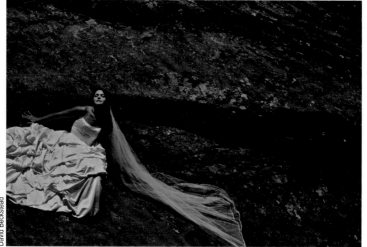

David Beckstead

David Beckstead

Her dress was blending in with the background snow. I changed my angle so the dress was in an area of different tonal values. She now is nicely separated from the background.

COLOUR DEPTH

Your eyes can distinguish shades of colour more easily than shades of grey. Often when converted to black and white the layers of colour end up being very similar in grey value, thus having the appearance of a decrease of depth. Of course it is an illusion, but a strong one in the interpretation of an image. The variations of colour in an image can seem to expand depth and sometimes "pop" the subject, often because of skin colour alone. Sometimes the subject is the only strong colour in a frame of monochromatic architectural buildings. I love to photograph subjects with architecture as a background and at times I use the subjects' skin tones to help separate them from the background.

David Beckstead

This black and white is a little boring to me. Nothing really jumps out, nothing is remarkable, because the tones are similar throughout.

David Beckstead

The skin tones of the bride and the green tones of the statue really help these elements "pop"!

GET TIGHT!

The fastest and easiest way to eliminate Visual Chaos is to get close, and crop tight. Of course I would not recommend this for every shot (that would be very boring). When the background is just too chaotic and there doesn't seem to be any visual relief, cropping tight could be a swift and simple answer to the problem. I not only crop tight: I consider the composition. I don't want it to be just another normal close up. I am looking for a way to crop more extremely... to give the viewer something different.

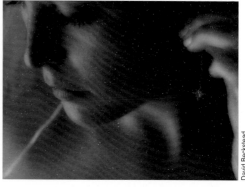

David Beckstead

Cropping tight helped guide the viewer's eye to her face and earrings. This is the story I wanted to convey.

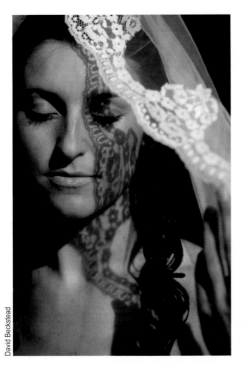

David Beckstead

Cropping in tight gave me a palette of Negative Space (her skin) to add a little controlled chaos of shadows. If I showed more of the scene, my effect would have been diminished.

FINAL STATEMENT

It is up to you to isolate powerful frames in chaotic visual environments. This is why they call us pros! Your job is to "see" at higher levels, gather up all the disordered state of elements, organise a coherent compositional path and give the viewer something not just anyone can do. Let me reiterate: eliminating all chaos it is not always the strongest concept. Giving the viewer some complexity and a path to follow that captivates them visually or emotionally and holds their attention longer is a goal I have for every image I take. A pro must balance just enough chaos against including too many elements that can clutter the frame. An image that fails to hold a viewer's attention, will often fall flat. I want my images to have the power to create "buzz" in my industry. I don't create images just for me. I want everyone to explore and appreciate them! By harnessing Visual Chaos you take the next step in understanding great composition. Don't avoid it, embrace it!

POSING AND PERSONALITY

Chuck Arlund is an amazing photographer so I was really pleased when he agreed to write a chapter on the way he works for me. Look at his website for some great fashion inspired images and workshops at www.chuckarlund.com

I hate the word posing. Most brides cringe in fear when you mention it. The reason is that images of military style line-ups of family and friends come to mind. "All of the bouquets forward and lean in. Now smile!" Everyone looks the same. They have a "beauty pageant" smile and it is not a very good representation.

Let's tackle families first. I like to have a little fun and mix it up. I almost never shoot a family formal at the altar. It is a busy background and there is usually just awful lighting. If I can, I like to get the family outside or just inside the entrance to the church. If that is unavailable I will put them in the pews and photograph looking towards the back of the church.

I love to see photos of real personalities. In order to get a real reaction out of people the photographer must have a personality and a little patience. It is a wonderful thing when grumpy Grandpa hugs his wife for the first time in 10 years. She loves it and the family eggs him on a bit. Eventually he smiles. I also love to have Dad or any other head of the family put their arms around their family .

For posing large groups, break it down into smaller family groups or age groups, then put them together with a person "tying" the different groups together. Have people sit and stand and let a person be the join between the groups. Let the pose or group have some space between people. It feels more fresh.

When posing a couple I try to think about relationships between the couple and the background. Is there a story to be told? Be patient. If you step in and immediately start shooting you are not giving the couple time to react to you or to each other. By having a little patience and waiting for the decisive moment you will cut down on your image- taking and make a better photograph.

To get a real reaction I will have the couple close their eyes for a bit. When you close your eyes the chaos of the environment goes away and it will let the couple really think about each other. When they open their eyes, wait for the shot. Wait for the look and ask for it. Practise with your friends.

Give the couple something to do. Running and jumping is great. If I am just not "feeling" a couple I will find a place for them to sit down. That will give you angles and give them something different to do rather than just standing there looking at the camera. This is great if you just can't seem to get any kind of good look from a standing couple.

Get the guy's hands doing something. Having hands in the pockets is cool and all, but when he is next to his beautiful wife or wife–to–be make him hold her. I like to take her hands and put them on his chest. Turn her around so she is falling into him then get her to pull his head closer with her hand. A great place to look for amazing couple shots is Ralph Lauren romance advertisements.

One thing to remember when photographing couples: if there is someone out of focus, do not have them looking towards the camera. It will draw attention to that person. There are a couple of instances when you might break this rule, but realise that the viewer's attention will be drawn to the out-of-focus person looking at the viewer. If the out-of-focus person is looking away from the camera then our minds accept they are like that, as long as there is a point of interest in focus.

LET'S TALK A LITTLE ABOUT PERSONALITY

How many of you like having your photo taken? I would say it is about half. Our clients are usually just like you, and most do not know what to do. If the photographer tells them where to stand and just starts taking photos, how do you think that couple feels? They are probably a little confused and are looking for direction.

Have some confidence and start the session with some very basic headshot sort of looks. The whole time you should be talking and getting to know your clients. When you feel they are loosened up, start moving into more full length shots. You will be able to direct them to do more interesting things after you have got to know them a little bit. It usually takes about 15-20 minutes before I really start to notice that the couple has relaxed.

I must admit, if I read a couple and they seem fun I will ask them if they just want to get right into it and get dirty? That is when I get them into what I usually do towards the end of a session: like her lying down on a bench with him romantically caressing her, while nibbling and tenderly brushing his nose against her cheek.

But see what I wrote there: "romantically caressing her, while nibbling and tenderly brushing his nose against her cheek." That is much more descriptive than "lie down and you get next to her, put your heads together and look at me. Now at each other, talk to each other, okay, back at me..."

"Close your eyes and melt into her, softly tell her you love her as she gently strokes your hair. Glance at me [female] as you [male] whisper 'I love you' to her with your eyes closed."

Tell him and her what to say. "Whisper something to her" might be okay but most people cannot think of anything to say and it is awkward. Having them close their eyes and telling them to tell the person "I love you" can be very powerful. Try it!

THE WEDDING DAY

BRIDAL PREPARATIONS

I like to allow plenty of time for the bridal preparations and often arrive a little early, giving myself the opportunity to assess the rooms, meet the bridal party and plan the posed shots I wish to create. It is important to have established with the bride beforehand the time you need to take the shots of her and her family. Experience has taught me that it is the make-up artist who usually runs late, meaning less time (if any) for the photographer. This impacts greatly on the coverage you provide. By addressing this before the wedding day you give yourself the opportunity to capture the posed and stylized images you have in your mind's eye.

In addition I like to discuss the bride's choice of location for her preparations. She may have chosen it with little regard for its impact on the photography. Quite often she will choose her parents' house, and although this may be perfect you might find that it is compact. If she has a large bridal party then space could be an issue. We should not dictate the wedding day but I see it as being professional to give advice on such issues to the bride and groom if we feel it could improve the quality of our work.

Ideally there should be natural light and enough room for everyone to move around freely. A hotel suite is often the best location for this. It would be ideal if located at or near the ceremony venue as it allows more time to photograph the groom. You are also able to go back and forth between the two. Regardless of the venue it is advisable to ask the bride to keep the room tidy if possible and to clear away (or have in a separate area) any food. Oddly, expensive wedding dresses often come on cheap plastic hangers so I ask the bride to take a few nice ones from home to hang the dresses on – details like this make all the difference to the image, inspire confidence in you and demonstrate that you pay attention to detail.

Look around the location for the best spots to photograph in as they may not always be obvious. Are there any pockets of light or directional light you can use? If there is a beautiful soft light coming in from a window, are there distractions on the floor or in the background which you need to move or avoid? Can you take a full length shot? How does the light change if you shut the curtains or blinds? Are there any chairs or a bed you can use for posing, and if at the bride's family home are there any artefacts from her childhood you can incorporate into a shot, or is there a mirror that you can use? Your mind needs to be open and to work quickly. Try to visualise the shot you will take; think about your lens choice and how that might change the whole composition of the image. You also need to think about how the images you take will sit together and tell a story within the album. Note which orientation you are shooting in and which way the bride is facing, and build a picture of the potential album design in your mind.

If taking group shots at this stage it may be an idea to place your subjects in an open front doorway where the light is generally good. This will naturally entice people to be close and pose in a flattering way. I often ask the bride and bridesmaids to have a group hug, then all to look at the bride, and finally to laugh. This creates natural reactions and emotion. When shooting inside, try to take the shot diagonally through the room as opposed to against a wall. This will add depth to your work. You might like to place the bride against a door and ask the bridesmaids to stand chatting in the background. By shooting wide open at f2.8 you will see them but they will not detract from the bride. Instead this will bring them all together.

If time allows, try to get as many must-have shots as possible before the wedding. These should include a full length, ¾ length, close up, a 2/3rds close-up shot of her face, back of the dress, full length of the bride with her bouquet and anything she has requested. You will then have your "safe" shots of these, allowing more time later to focus on the bride with her husband. You may also like to repeat them for variety and better choice of location. Remember not to shoot with a wide angle lens whilst close to your subjects as this will distort them. This is especially true in portrait orientations.

GROOMSMEN PREPARATIONS

The groom can often get left out of the wedding photographs as most time is devoted to the bride. This needs to be altered and we must make every effort to take images of the groom before the wedding ceremony. This may be at the place he is getting ready or at the venue if time is short. Once again the importance of this needs to be emphasized to the couple before the wedding, to allow time. I find the groom a little easier and quicker to photograph as there is no need for application of make-up, adjustment of hair and ensuring the dress is looking perfect. You can simply get on with it. Search for some suitable locations in great light and ask the groom to stand naturally. I try to get a couple of safe shots in locations most photographers choose to shoot in, and then actively search for less-used spaces. I often find these to be inside, where there are multiple areas in a confined space. Move around him to look for various shots with different angles. Can you find reflections or leading lines or can you find a position allowing you to shoot downwards? I am looking for images that other photographers have not taken before. Remember to use various lenses to vary the shots and allow creativity as well.

Bring the groomsmen into the photographs and have fun. I like to take at least one image of everyone where they are the focal point of the shot. This gives me peace of mind that I have at least one album-worthy image of every groomsman, as later in the day it can be too easy to neglect the ushers a little. Always be careful to ensure that their suits do not get creased or dirty.

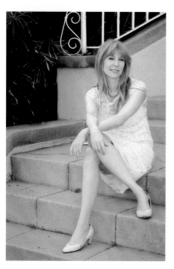 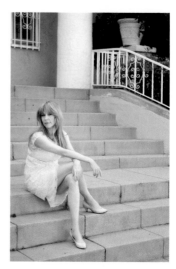

Occasionally as photographers we move far too quickly to get to a new location. This is not always necessary. David Williams taught me to make full use of the location that I am in. The series of shots on the following three pages was taken on the steps leading to Lisa's apartment, in the space of three or four minutes.

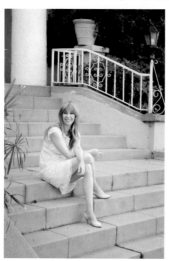 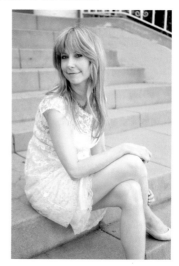

I simply asked Lisa to sit and stand in good clean light, and moved around her exploring different angles. As you can see I got a lot of variety and options which I could use in an album. The more you do this the easier it becomes to find good shots.

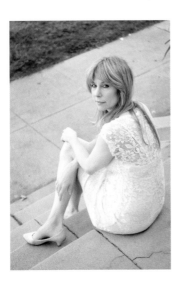
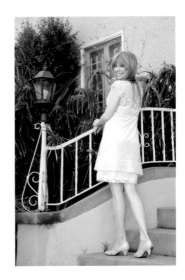

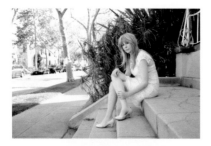

To further enhance your options shoot in both landscape and portrait orientation. Once I had exhausted shots on the steps we went to the front door. I was looking for reflections in particular. We got about 12 useable shots very quickly. Lisa did not get restless and we were soon able to move on to another location. Really look at where you are to see how many possibilities there are. Why not start at home today and try to find new angles that you had not thought of before. Can you use a zoom lens wide open to remove distractions, or position yourself in such a way that even your family would not know the shot was taken at home?

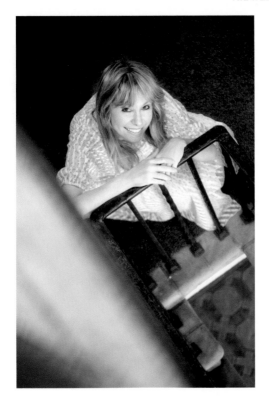

Inside the building there was a fantastic stairwell which was begging to be used. It was pretty dark inside so I had to search out the light and shoot at f1.4. I paid close attention to Lisa's hand positions in this series.

SIGNING THE REGISTER

You do not have a lot of time for this shot and all the guests will be waiting to take their own. I would suggest taking a standard shot with the bouquet on the table and the bride and groom seated and looking towards you smiling. You may then look for different angles, although space and distractions may limit this. Ask the bridal party or the witnesses to come forward and again take your safe shot and then ask everyone to look at each other and start to laugh. They will think you are a little crazy but say it with energy and meaning and they will. The resulting image will be full of natural emotion and joy. When the guests are taking their images go wide and capture this for a great supplementary image.

CAKE CUTTING

As with the signing of the register this is not always straightforward, due to space limitations and a plethora of guests also wishing to take the same shot. Take time to position the bride and groom and pay attention to their hand placement on the knife. Have the lady's more delicate hand on top. Observe the background carefully and if possible choose a location with minimum distractions . When they are cutting the cake see if you can move around to capture different angles, and zoom into the hands. The best shot sometimes comes after the actual cutting if they look at one another and smile naturally. Anticipate this and be ready for it, as with all aspects of the wedding.

BOUQUET TOSS

It is hard to pose the bride for this but you could quietly remind her to stand tall and elegantly. Look for the best vantage point and shoot away. It may be an idea to ask the bride to do a few practice throws first without releasing the bouquet. If you are able to suggest the best location then feel free to do so.

FIRST DANCE

The first dance is often filled with emotion, so hard to direct. We can give a few reminders though, and control the situation as much as possible. Speak to the DJ or band to find out the type and amount of lighting they will be using. This will determine what you should do. I often like to set up a video light on a tripod aimed

from above at the point where I anticipate they will be dancing. This allows me to ensure I have some useable light on them from the front and can also create silhouettes with rim lighting around their faces or upper bodies from the opposite side. I place this near the DJ or band so it mingles with their lights and there is less danger of a guest knocking it over. I always take a few shots with natural light and then with flash. I do this by shooting towards or across the DJ or band with a slow shutter speed and flash to freeze the movement. This should allow the natural light in the room to be recorded, hopefully including any coloured light coming from lasers or gelled lights. If there are lasers that are constantly on then ask for them to be switched off for the first dance as they will almost certainly show in your photographs.

A FEW MISCELLANEOUS HINTS AND TIPS

- Try to observe the rule of thirds unless you can break it successfully.
- When posing someone, look at how they are standing naturally and then add finesse to it. Look at the arm and leg positions. Are they flattering to the subject and if not how can you move them? Can you make the image more romantic or create intimacy?
- If you have a slim bride it is perfectly acceptable to have her move her hips away from you but then turn her shoulder back towards you.
- Pay attention to where the couple are looking – you will find that in some of the best images no-one is looking at the camera. The shot is about the two of them and not you.
- Change your angle and lens for different looks. A wedding all shot from eye level on the same lens gets pretty boring.
- Ask yourself if this is an album-worthy image before shooting it. Is this image the best you are capable of or could you improve it?
- Slow down and take a few excellent shots instead of many mediocre ones.
- Can the subject lean on anything or sit on anything?
- Do not shoot close to anyone with a wide-angle lens as it will distort them.
- The difference between an okay shot and a good one is often down to small changes. If you focus on the details and consider the image you may be able to transform it.

Distortion with wide-angle

Distortion free at 80mm

- If you want a happy smiley shot then ask the subject to think of something that makes them happy, or put ideas into their heads.
- Never forget that it is about the light.
- Keep a careful eye on the background for distractions. These may be items growing out of people's heads, or a bright light. Try to compose without distractions. This will give you clean images.
- Engage the couple with your personality to get natural happy expressions.
- Do not pose to a formula – it is like posing by numbers. You want natural images

MISTAKES TO AVOID

Wedding photography is subjective so this is a hard paragraph to write. My view is that you are one of two types of wedding photographer. One type of photographer asks the bride and groom for input and any shot requests they have which they then comply with. There is nothing wrong with this, but I would suggest that most photographers, as artists, would prefer couples to choose them for THEIR photography skills, art and vision. By improving ourselves and our abilities we naturally move away from being the first type of photographer (who pretty much photographs by numbers) to being the second type, with artistic ability and style. Couples will clearly see this and be willing to pay more for it, assuming your marketing is good as well.

A number of readers will easily fall into the second category of photographer, whilst some will aspire to it. To get there you need to be consistent, avoid cheesy images and use few if any digital effects like spot colour or zany digital album designs. Your posing needs to be clean, in good light or well lit and have elegance and finesse. Getting to this level is relatively easy – it just take practice, passion and focus. Once at a good level the learning curve flattens and you progress more slowly, adding more layers of finesse, storytelling and technical ability to your work.

So what makes a cheesy image or a bad pose? A cheesy image might be described as a cliché: someone poking their head out from behind a tree, the groom looking at his watch in a very posed fashion, a bride looking surprised at something, a garter on the bride's leg, the groomsmen holding the bride up, the "Reservoir Dogs" shot of the men, the groom on one knee holding the bride's hand, the best man looking at the bride and groom in a posed voyeuristic manner, or even the use of direct flash. Unless you have an original and excellent variation on these they should be avoided. Eliminating them is more consistent with the style of work taken by leading professionals. If you can draw inspiration from them (as shown in this book) and progress your abilities you will develop quickly and your business will grow.

Bad posing is essentially where the subject is not in the optimum position to look elegant, refined and beautiful. This may be:

- an arm hanging down when it could be wrapped around the bride's waist
- the subject sitting down and their corset/waistcoat pushing their chest up
- the bride standing straight on to you, instead of at an angle with her weight on the furthest leg away from you (always try to have the hips going away from the light source to aid thinning)
- having arms and legs not bent (if it bends then bend it)
- having a bride lie down and look back at you causing her to have wrinkles in her forehead
- having the bride lean against or onto something so her elbow is inverted
- hands fully in pockets (never ask the men to have their hands full in their trouser pockets. Instead ask them to place them only slightly in so that the tip of the thumb is on the outside of the pocket)
- having heads straight – it is always worth having the head tipped slightly to one side
- the wrong expression for the pose – it is important that the expression matches the pose
- the wrong pose for the body type or personality – there is little to be gained from trying to do a high fashion pose from a low angle with a larger person as it simply looks silly. The pose should be suited to the individual
- tilted images. In my opinion tilted images show a lack of compositional skill and imagination. When included in an album they confuse the viewer's eye due to horizon lines at various angles. There are times to tilt though, such as when a subject is in motion or you are cropped-in tightly and there are no horizontal or vertical lines. Otherwise please avoid. Look at the gallery at the back of this book and notice how many images are tilted. The answer is virtually none. The one exception is if it will be a feature image on a page and works compositionally perfectly
- Spot colour. We should never use spot colour – it is old fashioned, dates easily and is visually horrific. I fully realise that this will offend a number of people but please move on from it. It does not matter that your clients love it, as your clients should be choosing you for your artistic ability and vision.

Our aim is to create poses that flatter our subjects. Remember to ensure that arms are away from bodies to aid slimming and also ask your subjects to lean forward slightly and raise their heads to avoid double chins. This SHOULD NOT be highly visible in the image – it should look natural. If you are having trouble getting someone to smile naturally, ask them to sing the letter E happily. Try this yourself – it makes the mouth naturally adopt the smiling position. Done in unison it may well inspire the bride and groom to laugh naturally together, resulting in beautiful posed but natural shots.

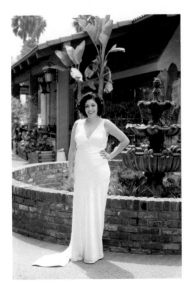

The light in this image is soft and backlighting our model, Mindy, but the shot is ruined by her pose. She is straight-on to the camera and, worse, she has a tree directly behind her growing out of her head.

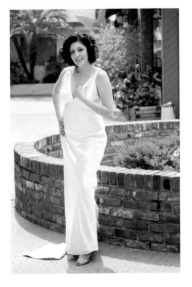

By moving yourself to the left or right you can often avoid distractions such as trees growing out of people's heads and create a far more pleasing image. It is still not perfect but a vast improvement.

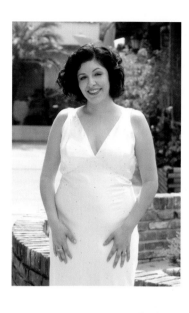

I have included this image
again how an incorrect pose
and is unflattering to your subje

This is better. Mindy is now at 45° to me but I think she could benefit from having one arm up towards her chest to break the pose a little. Have you spotted the deliberate mistake? Mindy is posed well but has two "bunny ears" appearing from her head. There are so many things to think about when taking an image that it is very easy to miss one. The solution is to slow down and do a little check of the main points such as pose, clean background and good light. Weddings are fast-paced events and mistakes can and do happen, so just try to eliminate as many as possible leaving you with more images that you can use.

THE WEDDING DAY
...e to show you
...ains a shot

...ng album should be as timeless as possible. Therefore we ...hat could date it, which usually means the design. The design ...ell a story. We should avoid cluttered pages and any digital ...colour, coloured borders and irregular shapes or ovals. Pay ...ur palette on the page: do the images work together in terms ...ofdvise not to mix black and white and colour images on the same page either. Where possible the horizon lines should be in line with one another to create calmness.

Think how the posed images look on a page. Are the people facing in or out of the page? By designing the page so the subjects look inward, the viewer's eye will follow. I always try to ensure that the posed images have prominent space within the album, with usually just one or two per page unless I am creating a sequence.

Hollie Marie

Humza Yasin

MODEL, ENGAGEMENT AND POST-WEDDING SHOOTS

MODEL SHOOTS

Having read this book it would be rather unfortunate to put it in your camera bag and not practise what you have learnt. Like anything in life, practice makes perfect and a real wedding is not the time to do this. I strongly suggest getting together with some friends or your partner and practising. Use this book for inspiration and see the difference that little changes to head, hand, arm and leg positions make. The more you do this the more confident you will become. Practise your wireless off-camera flash work until you are really proficient and confident with it. Once you have mastered the basics then you can start to look at the more advanced poses and start to visualize how these can be incorporated into weddings that you shoot. If your friends and family are not willing there are many sites online to find models, such as www.modelmayhem.com, www.purestorm.com or even try Craigslist. Simply offer your services in exchange for a CD of the images for the model's portfolio. These practice sessions can be the most important training that you do.

ENGAGEMENT SHOOTS

Doing an "E-Session" can be hugely beneficial to you and your couple. It allows you to build on the rapport you started at your very first meeting. Most couples have not been photographed professionally before and therefore may lack self-belief and confidence in front of the camera. This is perfectly understandable as they are accustomed to seeing photographs of themselves taken by friends with a compact camera, constant large depth of field and often with unflattering light or direct flash. This is your opportunity to build their confidence and show them how great they can look.

Start off with some easy shots so you and they can warm up and really get into the session. Remember to be confident throughout and positive about how they are doing and how they look. When you have some nice images, show them on the back of the camera. This will really help them. Use the session to make observations about them (and write them down afterwards in the file). Look to see how they act with one another: are they touchy-feely; are there cute looks between them with lots of romance; or do they find it hard to express themselves in public? Your job is to bring out the best in them, so react to their personalities. If they are a little uneasy about expressing their love then slow it down a little, speak a little more softly and try to encourage them.

Talk about your style and explain that you don't always want them to be looking at the camera, as the shoot is about them. Ask them to think about a movie and how often they see an actor looking directly into the camera. It is hardly ever. Feel free to show them this book as a visual aid to what you wish to achieve – this can be a lot easier than trying to articulate your thoughts. It is also a great time for you to move out of your comfort zone. Pre-plan 10 shots you would like to create, that you know will work with the couple and that you have not taken before. Maybe you could have a little theme for the shoot, such as reflections or leading lines, and look for these throughout. You can use equipment you may not currently use, such as a reflector of off-camera flash – it really is an opportunity for you to play and practise for real what you have learnt here and in your model shoots.

POST-WEDDING SHOOTS

If your couple is willing, these sessions can be great fun and a good source of extra income for you. The chances are that couples who wish to do this are confident in front of the camera and you can really push your creative boundaries. These sessions are most commonly known as "Trash the Dress" shoots. The wedding day has gone and the bride has no use for the dress any more, so why not destroy it in style and record it on camera? Your imagination and safety are the only limiting factors here. Many choose to go to scrap yards, or to the beach or a lake where the bride can enter the water for some spectacular imagery. One of the original and best proponents of this is John Michael Cooper. His cutting-edge imagery is simply sensational and I cannot fathom how his mind works, it is so creative. You may have seen some of his work, such as the dress on fire, the bride with a spade and the groom in the trunk of a car, or the floating bride. Look at his website at www.altf.com and take one of his courses to really explore and push yourself to the limit.

You may wish to theme the session on the couple's interests so it has an underlying meaning for them. At the time of writing I am about to do one with a couple into rock climbing. This should be really good fun and they will be able to look back in years to come and invoke great memories of their passion. If you are going to use water then obviously you need to be prepared and ask the bride to come with towels and a change of clothes. They will also need a place to get changed. Make sure that you take any water shots at end of the session so as not to ruin hair and make-up. It may be an idea to rent some waterproof housing for your camera.

We have developed a series of exercises for you to shoot to build your skills. Try to master each one, as they are valuable in your development and will teach you to see in a different manner.

1. Photograph an egg in 20 different ways. This sounds crazy but it will teach you about light and being creative. The only rule is that you cannot move the egg. Use different lenses and flash, and vary the angles: all must be

substantially different. Then put them all together on one print and print out. This will be useful to you when shooting detail shots.

2. Position a model in front of a window and move around taking shots. Use different focal lengths and lenses and move the subject around in that area. How many different shots can you create in that one spot?

3. Place a subject in good light and position the hands in as many flattering ways as possible. Do this with the subject standing up and seated.

John Michael Cooper

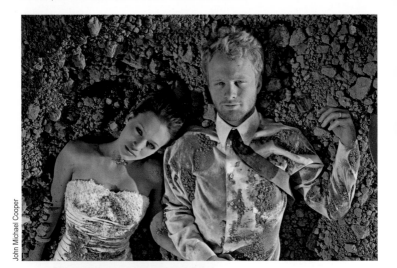

John Michael Cooper

John Michael Cooper

You may wish to theme the session on the couple's interests, so it has an underlying meaning for them. At the time of writing I am about to photograph a couple into rock climbing. This should be really good fun and they will be able to look back in years to come and evoke great memories of their passion.

WORKFLOW AND PHOTOSHOP

Michael O'Neill publishes a great educational BLOG called "The Pro Spot". He has kindly written this article for you on his workflow giving hints and tips on how to cut down the time you spend behind your computer. www.michaeloneillfineart. com/prospot.

I don't think we can start any discussion on the subject of post production workflow until we define the word "Editing." "Editing" is simply the act of sorting through your images, picking out the best, throwing out the bad and organizing for use later. "Editing" does not mean enhancing images, applying effects, retouching or using Photoshop to try to rehabilitate poor images. "Editing" is simply culling the best of similar images, adjusting colour and exposure to perfection, applying some light enhancement (such as edge burning to portraits) and outputting those adjusted files for archiving and use in album production at a later date. The goal of my post-production workflow is twofold: first, to provide previews (proofs) to my clients from which they will choose the images that will ultimately make up their finished wedding album; and second, to give me the organized body of images on which I will work later in Photoshop when creating my client's finished album. It is an abominable waste of time and not cost-effective to attempt to enhance or artistically interpret every single image you take on the wedding day.

I do all my editing in Apple's Aperture application. A great many photographers use Adobe's Lightroom. Both programs are very similar and their power comes from lessons learned over decades from film photographers. For starters, the interfaces of both Aperture and Lightroom are designed to look like a film light box. In the "old days", film photographers would take their processed transparencies and lay them out on a light box, side by side, for comparison. We do the same thing now -digitally. Both Aperture and Lightroom automatically display (stack) all of our similar images side-by-side for our comparison. Today we can digitally rate our images, assign values, embed voluminous metadata for use later on, and make adjustments for colour temperature (white balance), hue, contrast, black level, highlights, shadows etc. We can look at the first image on our computer monitors, and then apply any compensation to every other similar image in a matter of seconds. The process is now completely non-destructive.

On an average wedding assignment I will bring home 800-1,200 images and I will process them all in under two hours. How is that possible? First of all everything is shot in the RAW format. With today's software solutions for RAW image processing there is no reason to compromise the quality of your work by shooting in the JPEG format. Professional DSLR's offer RAW image capture for the ability, after the capture, to modify exposure, colour balance, hue, saturation, contrast, black point, highlights, shadows, etc. Secondly, nearly every image I make on the wedding day

is captured in manual exposure mode. Consistency is the name of the game for an efficient workflow. At every event I'll capture any number of different images of the bride and groom alone, in under 5 minutes, in one location. Every one of those exposures will be identical in manual exposure mode! No camera, no matter how advanced, will deliver that consistency in program, aperture priority or shutter priority mode - period. If I need to make an exposure compensation or a colour balance adjustment after the fact, I'll make that adjustment to one image and then apply that adjustment to the other images in a matter of seconds.

All three of my Nikon D3 cameras have their internal clocks synchronized, so when I import my images into Aperture (or Lightroom) every image is displayed chronologically regardless of which camera body it was captured with. Using the auto stack feature in Aperture displays all of the nearly identical images I've captured, side-by-side, for instant comparison. I'll navigate through the entire project twice: once to make the image corrections previously mentioned, then a second time to rate the images. After I have rated all of the images I use Aperture's "sort" function to display only those images which I have chosen to keep. I then export all of those sorted images as full resolution JPEG files with a custom name and sequence number starting with number 001. Those are the files that are archived on my computer. They are then backed-up on my RAID storage device, on an external hard drive, on a DVD and uploaded to Pictage for remote storage, online display and sales. The original RAW files are then thrown out. I use the high resolution JPEG files for everything thereafter.

My final image retouching and enhancements are undertaken after, and only after, my clients choose an image for their finished wedding album. I have a sample book in my gallery displaying some before and after examples of the kind of image enhancements my clients can expect. I show this book to my clients the first time they come in to consult with me for their wedding, so they know what to anticipate in the finished product. The clients see this book again when placing the order for the finished album. It helps them visualize what their finished images will look like after I work my "magic" in Photoshop. I do use some third party software solutions in my retouching efforts, including Nik Software, Kevin Kubota, Kodak's Digital Gem Airbrush Pro Filter and Yervant's Actions. Bear in mind that these tools empower you, as an image maker, to work more efficiently, but there is nothing in any of these filter/action products that you can't accomplish within Photoshop itself. Actions simply automate the steps that you would take within Photoshop to create the desired effect.

SOME TIPS ON RAW IMAGE PROCESSING

Once again, consistency is most important. Your computer monitor should be properly calibrated and reside in a "clean" room. The walls in my computer room are painted approximately 18% Grey. There is very low indirect lighting in the room

and light cancelling window treatments keep the ambient light in the room constant regardless of the time of day. Simply stated: my monitor looks the same all the time.

When doing my basic corrections and converting the camera RAW files to the JPEG files, I always correct the density (exposure) first. This, too, is a lesson learned in the darkroom from the "old" film days. You can only see what colours might need to be corrected in an image when you are looking at it properly exposed. (An old darkroom trick with images that are difficult to colour correct is to print the image lighter than it should be, making the bad colour less apparent). I use the image on my properly calibrated monitor as my guide. If you doubt the accuracy of your display you should use the histogram when adjusting exposure.

Wedding images are so very easy to colour correct as it is easy to see any off-colour shift in the bride's white wedding dress. Once the density (exposure) is correct I will adjust colour temperature (white balance) as needed. Sometimes a hue adjustment is also necessary. I often find it necessary to shift the hue slightly to the magenta side after correcting white balance on a scene that was lit with a dimmed tungsten light source. This sometimes becomes necessary when I've set a pure tungsten white balance (3400K) in my camera. As pure tungsten lights are dimmed their colour temperature shifts away from 3400K, requiring this hue adjustment in RAW image processing. It is much faster to make this adjustment on the computer than to set up a custom white balance in the camera while shooting. Oh, the sheer joy and simplicity of digital photography. In the "old" days we would have had to take readings with an expensive and complex colour temperature meter and then filter the camera's lens with a combination of exposure shifting colour correction filters in order to get accurate colour on film. The freedom from these technical restrictions has allowed the savvy digital shooter to explore truly unique and flexible lighting opportunities in the fast-paced world of wedding photography.

At this point only will I make any highlight and shadow adjustments. Care must be taken when using these adjustments in RAW image processing applications such as Aperture or Lightroom, as severe noise can be introduced into your image if you use too much highlight or shadow adjustment. In my fine art work I will often open my images and make my Nikon camera's RAW image adjustments using Nikon's Capture NX2 software. The proprietary algorithms in the Nikon RAW image can only be leveraged with Nikon's Capture NX2 software. Neither Aperture nor Lightroom can process a Nikon RAW image like Capture NX2 can.

The final step in my RAW image processing is to burn the edges of my portraits (Vignette function). When my image is done I copy the adjustments I've made and paste them to all the similar images in the stack. Though it took five paragraphs to describe all of this, with practice the actual process takes only seconds!

THE MAGIC OF PHOTOSHOP

As photographers we now have at our disposal one of the most powerful creative tools we have ever known: Photoshop. Photoshop is an enhancement tool for fine images, not a Band-Aid for poor photographic captures. The old adage of "Garbage In, Garbage Out" holds painfully true in the art of photography. When I sit down with a prospective bridal client I tell them that a photographer's job is not done when he or she releases the shutter on their camera. I then go on to show them some dramatic before and after images of what Photoshop enhancement is all about. I'm going to share some of those images with you while describing the techniques I employ to achieve these results.

A CLOSE-UP GLAMOUR PORTRAIT OF THE BRIDE

A few steps were taken to enhance this traditional window light portrait of the bride. I started by using the clone tool in lighten mode at an opacity of about 12%. Selecting a light area on the bride's cheek, I cloned repeatedly over the lines and dark areas around the bride's eyes. Always work at a low brush opacity and build up the effect slowly when employing this technique. Next I created a duplicate layer; selected the bride's face, chest and arm with the lasso tool; feathered the selection by 20 pixels; and applied the Kodak Digital Gem Pro Airbrush Filter at its default settings. Using the eraser tool at 100% I totally erase the airbrush effect on the bride's jewellery, mouth and eyes. I then reduce the layer opacity to around 50% (as the airbrush effect is just too strong) before flattening the image.

Next I apply unsharp filter masking to the entire image at around 150% with a radius of 2 pixels. Note: this is excessive sharpening and will introduce a huge amount of digital noise into your image. I then take a snapshot of the overly sharp image and undo the unsharp filter masking (Edit > Undo Unsharp Filter Mask). I select the sharpened snapshot for use with the history brush and start painting the sharpened image, with the history brush, just into the bride's dress detail. I then use the burn tool to darken the bride's dress detail, to burn the corners of the image and to darken the side of the bride's face to add more contour. Again, use the burn tool

 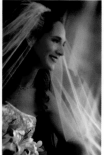

at a very low opacity and build the effect up slowly. Again I create a duplicate layer, apply diffuse glow to the image, and use the eraser at 100% to wipe the glow away from everywhere but on the bride's veil. I lower the opacity of the duplicate layer until I like the glow effect on the veil and again flatten the image.

Finally I apply a gaussian blur at around 12 pixels to the whole

image, take a snapshot and undo the blur. Using the history brush one more time I paint the blur back into the background in the upper right hand corner, effectively removing the distracting window shades. From start to finish this enhancement took about three and a half minutes.

DETAIL SHOT OF THE BRIDE'S DRESS

Just a few simple steps in Photoshop transformed this simple image of the bride's dress into a 2008 WPPI Accolades of Excellence Award print. The detail on the back of the bride's dress was sharpened using the unsharp filter mask and history brush

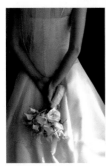

technique described previously in the glamour portrait. The image was then selectively darkened with the burn tool, wiping out the distracting elements in the background and drawing the viewer's eye towards the bouquet of flowers by gradually burning outward from the perimeter of the flowers towards the edges of the print. Finally a diffuse glow was applied to a duplicate layer and the eraser tool was used at low opacity on that layer, to gradually reveal the detail on the upper back of the dress and to remove the glow from the bride's arms (leaving a wonderful diffuse glow on the lower portion of the dress and also on the flowers). This simple enhancement process with dramatic results took less than two minutes to complete.

CROSS PROCESSING

Here's a dramatic technique that you can execute in Photoshop that emulates, with incredible precision and predictability, a photographic technique that was employed extensively in the film era after being discovered accidentally. The first cross processing effects were achieved by processing colour print film in E-6 chemistry: the materials designed to process colour reversal (transparency) film. This method produced a positive image on the orange base of colour negative film. Today this effect can be emulated in Photoshop with infinite adjustment over the final colour toning.

I start by converting my colour image to black and white. I have dozens of different ways for doing this, depending upon the tonality of the image I am working with, so I can't possibly discuss all of them here. Pick a method you are comfortable with that yields a nice black and white image with good highlights, shadow detail and blacks. I then duplicate the layer, and then create a curves adjustment layer (Layer > New Adjustment Layer > Curves). The curves dialog box will open up and a graph

showing four independent channels (Red, Green, Blue and RGB) will be displayed. (You will note that a cross process choice appears in the drop down menu. Resist the urge to use it. It returns a default mediocre result that does not have nearly the dramatic impact I'm showing you here). The effect I have chosen here was created by adjusting specific individual layers in the RGB choice as follows: increase the highlights and decrease the shadows of the red channel and decrease the highlights and increase the shadows on the blue channel; leave the green channel alone (the effect you see on screen will look blown out and overly saturated with wild vibrant colour. Don't worry.); reduce the opacity of the adjustment to approximately 50%

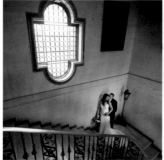

and merge this adjustment layer with the duplicate black and white image layer below it; finally, downwardly adjust the opacity of this merged layer until you reach the cross process effect you are looking for and flatten the image.

On the final flattened image I did some burning around the edges of the print to draw the viewer's eye towards my subjects. I also used the command Edit > Transform > Skew to remove some of the distortion that was introduced into this image by shooting downward towards my subjects with a 17mm wide angle lens. The effects you can achieve using this process are limited only by your imagination and the amount of time you have to experiment. I suggest you keep notes as you experiment so you can remember exactly what adjustments you made, when you finally achieve that perfect look.

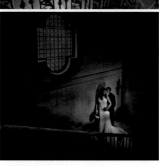

CONCLUSION

These are just a few of the myriad techniques I use when enhancing my images in Photoshop. The possibilities for creating fine works of photographic art are only limited by your imagination and the time you invest in research and experimentation. There are countless resources, such as this fine book, available to you. I encourage you to visit my professional photographer's web site, The Pro Spot (http://michaeloneillfineart.com/prospot/), where I share my techniques and philosophies on a regular basis. Make your photographic capture the best that it can be, streamline your workflow for efficient use of your time, and budget some all-important quality time for researching and practising your craft.

POSING HANDS

Hands are incredibly difficult to pose correctly. They can look awkward, disjointed and ugly if not positioned correctly. It is such a small detail yet one of the most crucial in elevating your work to the highest level. I can think of no-one better than Andrena Douglass at posing hands, so am pleased to present this gallery of her work. To view more, visit her website at www.andrenaphoto.com.

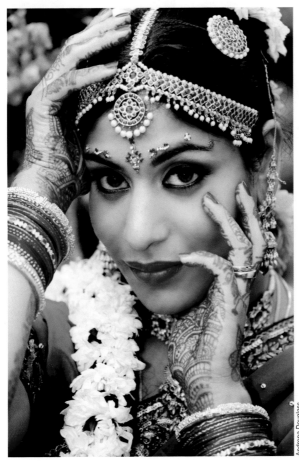

Andrena Douglass

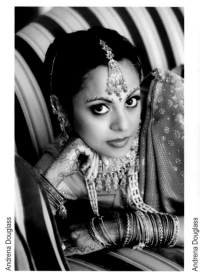

Andrena Douglass

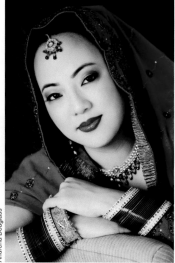

Andrena Douglass

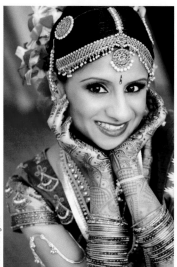

Andrena Douglass

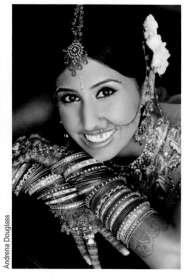

Andrena Douglass

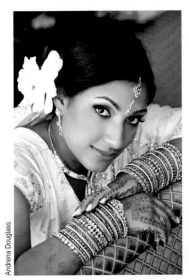

Andrena Douglass

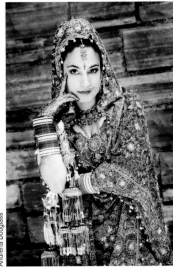

Andrena Douglass

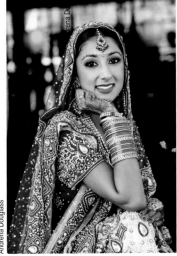

Andrena Douglass

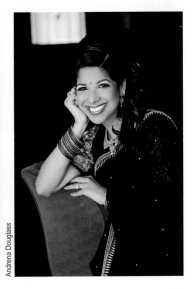

Andrena Douglass

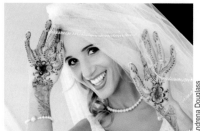

Andrena Douglass

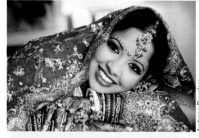

Andrena Douglass

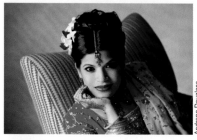

Andrena Douglass

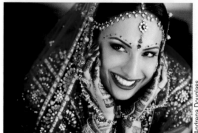

Andrena Douglass

OFF-CAMERA FLASH

Off-camera flash and video light work can be quite daunting at first, but once understood they add a totally new dimension to your work - and one that any amateurs at the wedding will not be able to copy.

My friends Mike and Cody at Tri-Coast Photography have given me permission to take information from their excellent self-published book (TTL Wireless Flash Tips and Tricks) to use in this chapter, as there is no point in re-inventing the wheel. I am very grateful to them for sharing. Of course a pocket book can in no way cover all the details relating to off-camera flash, as it can take up a book by itself. I suggest that, unless you are 100% familiar with how to operate your flash wirelessly, you get a copy of their book to familiarise yourself with the theory and techniques needed. You can get a copy direct at www.tricoastworkshops.com - it is well worth the investment. This chapter will assume that you are familiar with wireless flash operation via in-camera mode, radio poppers, pocket wizards or other devices that are on the market. The chapter will be specific to the bride and groom formals. It can of course be used at any time during the wedding but I would suggest not during the ceremony in case it is intrusive.

Being able to use off-camera flash well is a great tool to have in your arsenal as it can transform your images and the quality of work that you produce. For example, did you know that you can very easily make it look like midnight at midday and correctly expose the bride and groom? Perhaps you are working indoors and would like to direct some light onto your subjects to highlight them? Being equipped with the ability to use TTL Wireless Flash opens up new opportunities for you and, as a result, further sales -as the look you create will not be able to be copied by guests at the wedding.

Before you use Wireless TTL Flash you should have an idea of what look you are trying to create. There is little point in using it simply for the sake of it. I would suggest that in your own time you find some models and practise various poses using wireless TTL Flash. This will give you a backbone of knowledge and ensure that you can then replicate those images anywhere in the world. This proves very useful if you find yourself working in a less than glamorous location or the light is poor quality. By practising, you will be able to get a series of safe shots that will impress and that you can take quickly.

Once you have determined that you are going to use Wireless TTL you have to decide on the placement of the flashes in relation to your subjects. Do you want to light their faces completely or generate some modelling light? Do you wish to light their clothes at all? One often overlooked feature is the ability to zoom in your flash head onto the subject. Much like a lens, you can zoom the light so it gives only a

narrow cone of light. Conversely, if you leave the flash on its wide setting (usually recommended) at about 24mm you will get a wider pool of light. You cannot control this by any means apart from on the flash itself. It is worth experimenting to see this in action: place a model near to a window and another a few feet away but in a darker area. Take the shot with the flash at 24mm and pointing to the person in the dark area (being careful to expose for the person by the window). They will be very minimally lit. Now increase the zoom on the flash to 70mm. It will make a difference and light the person a little more. Finally zoom the flash head right in to 105mm and you will see the person is now in striking light, adding a new dimension to the image. You may like to experiment a little with the flash-to-subject distance to see what effect this has.

Ratios are an important aspect of flash photography so it is worth mentioning them briefly. Firstly you need to determine what your main light source is: if shooting outside in the sun then that is the primary source and your flash would generally be used as a fill or hair light. You would not want all sources of light to be outputting the same power, so you can control your flash in three ways. You can either turn the power up or down, use the flash compensation button on your camera, or simply move the flash closer or further from your subject to give the desired effect. This will be determined by the look you are hoping to achieve. An example would be creating a strong hair light or backlight, giving a fashion look, by increasing the ratio.

Often when shooting outside the sky can be a mild blue or grey and a bit washed out. It looks okay in photographs but hardly sensational! One way to overcome this is with Wireless TTL. Mike and Cody advocate shooting in A mode outside in daylight so that the camera can calculate the shutter speed for you (remember the usual rules about regular exposure compensation for very dark or light backgrounds), freeing you up to focus on the image itself. Most cameras have a maximum sync speed of

1/250th of a second, which when outside and wanting to shoot at f2.8 will give a very over-exposed image. The solution is to turn on the high speed sync function within your camera's menu (for an explanation of this refer to Tri Coast's book) but remember that the faster your shutter

speed when shooting with high speed sync on, the closer the flash will have to be to your subject for the light to register.

Let's assume that the settings your camera gives for a given scene (in A Mode) with a bright sky and a subject in the foreground are 1/320 at f2.8 and ISO100 (with you exposing for the subject). You will capture an okay image. Now change the shutter speed to 1/600 but keep the other settings the same. You will notice that the sky has gone a much deeper and richer colour but your subject is very underexposed. This is because the ambient light reaching the sensor has been reduced by the increased speed of the shutter. Play around with the shutter speed to achieve the colour you are looking for. You now have your background exposed for this image exactly as you want it. The image can now be thought of as two images – a foreground and background. The background is lit but the foreground is not, so it is time to introduce wireless flash into the equation to light the foreground. The beauty of TTL is that the flash will do all the work for you, and light your subject fairly accurately. If it is not exactly as you wish then adjust the power output on the flash unit until you are happy with the result.

Using this technique, and freeing you of wires, means you effectively make the world your studio. You have the option to make the flash the predominant light source or to use it as a fill light in harsh sun. It also enables you to shoot into the full sun and control how that looks. In the above examples the f/stop was wide open which would (if shooting into the sun) render it as a bright fireball with very soft edges. If you take the same image and stop down to f/22, for example, the sun will render as a starburst with visible rays emanating from it. This is the same technique used to turn midday into midnight, as the image will be pretty dark with the exception of the sun and your subject , which you have lit with your flash.

To really elevate your work it is important to understand lighting patterns and how they affect your final image. You should generally be using the most flattering light for your subject.

SHORT LIGHT

This is when the light is hitting the side of the face that you see the least. The light falls off on the opposite side (furthest from the camera) creating a thinner appearance which all brides love! It is therefore a very flattering form of light. The easiest way to achieve this is to pose your subject normally and ask them to turn their face slightly towards the main light source (either a window or flash). This pulls the short side of the subject's face away from the camera and towards the light source.

BROAD LIGHT

This is the opposite of short lighting, and is when the light hits the side of the face you can see the most. This creates a wider face so should only be used on smaller or slimmer people.

BUTTERFLY LIGHT

Modelling light is another term to describe this pattern of light. The light comes from above and is slightly in front of your subject. The light drops off the cheekbones and chin, creating a more dramatic look and shadow under the nose which looks similar to a butterfly. This is best used on ladies to create drama or with a reflector or wireless flash to add a kicker.

On occasions it is beneficial to shoot upwards from a low angle . This has many benefits including the illusion that the subject is taller, which also thins them down. Be careful though only to shoot these images with a wide lens, otherwise you will be looking up the subject's nose if captured close up. By adding a TTL wireless flash to the shot you can also help to minimize any double chins. Place it up high and pointing down on the subject.

All of the above can be taken with your Canon or Nikon camera used in conjunction with the wireless systems they use with their Speedlites. This is fantastic but has one limitation: they both rely on having a line of sight between the camera and flash to work, because they operate using an infra red signal (not radio waves). This means that if you place your flash behind an object then the flash may not pick up the signal emitted by the camera controlling it. This problem has been solved by the Radio Popper (www.radiopopper.com), which cleverly decodes the signals and sends instructions via radio waves to the flash. This eliminates the need for the camera and flash to have a line of sight, thus opening up a new world of possibilities. By using this system you can now use softboxes to gain a very soft look to your images (remember the larger the softbox is and the closer it is to your subject, the softer the light will be). You may like to pose your couple outside at dusk with their wedding car, in which case you should place a Speedlite inside the vehicle with a coloured gel to add interest to your images. Perhaps you are shooting through a doorway into a large hall where the light falls off dramatically. You could place your Speedlite in that room and light it up to add depth to your work.

You are not limited to just one Speedlite either. Imagine the images you could create (subject to time) with multiple units. The opportunities for creativity are almost endless. The most important factor when using TTL Wireless Flash is to practise. A wedding is not the time to do this. Find a couple of subjects and a photographer friend and spend time practising. Try to find locations that emulate what you might find at a wedding venue (ask a local venue if you can go there in return for some

publicity shots for them). Move the lights around, shoot at different times of day, look at the ratios and really understand what you are doing. Get to the stage where you are comfortable and can do this anywhere. Once you grasp the concept then it is really very easy to do and gives you the edge over your competitors.

VIDEO LIGHT

The main difference between TTL Wireless Flash and video light is that the video light is an independent light source and not controlled by the camera. It is up to you to move the video light closer or farther away to control the amount of light falling onto your subject, and its intensity. Think of it very much like a torch but with a warmer light. Some models, like the Lowel id, have a dimmer lever and also the ability to focus the light (that is: to make it wide or more zoomed in) which is very useful.

The light achieved with a video light is a lot warmer and usually a lot less powerful, so is mainly used indoors or at dusk or night-time outdoors. It can give a very 1950's Hollywood feel to your images. One of the great advantages of the video light is that it gives you the ability to see exactly where shadows fall on your subject's face (this will also help you to learn good placement of Speedlites) so you can make instant adjustments. This feedback is very useful in determining the final image.

For an artistic-looking image, place your subject near a natural light source such as a large window. You don't want them too near but in the sweet zone of light (usually 12-36 inches away). Pose them as normal and shine the video light onto them so it is reasonably strong. You should have an acceptable image. Now change your white balance to Tungsten and retake the shot. You should find that the camera has rendered the window light blue and the video light a beautiful contrasting warm tone. It is a nice look if used sparingly.

 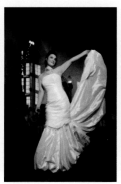 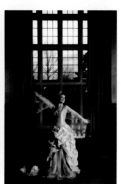

All taken with off camera flash.

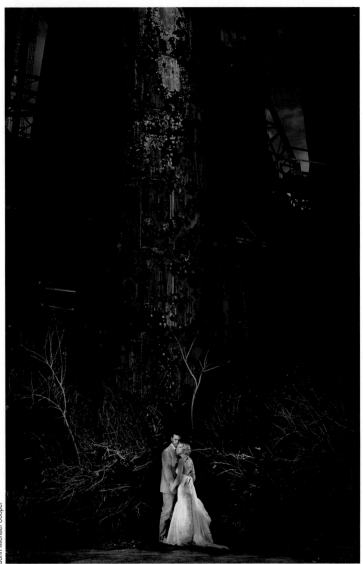

Wedding Photography
A Guide to Posing

THE GALLERY

The following gallery has been the hardest part of the book to compile. It took literally months of research to select and invite contributions from the 70 photographers whose work is showcased here. Each sent in a number of images which we tried to edit down from 2500 to 300. As each image was taken by a superb photographer it proved very hard. In the end we had some 450 images that we simply had to use and get releases for. Not an easy task!

Is every image perfect in every way? The answer is no – that would be almost impossible. Photography is very subjective and what one person loves another will dislike. I do believe that every image is of an excellent quality and worthy of a place here and in the couple's album. As the images are so subjective you may well find contradictions from what has been written in the previous chapters and the descriptions of other images. This is FANTASTIC. It means that you have taken in what has been written and formed your own opinions. This is intentional and is the first step in creating your own style, which is what we all ultimately wish to achieve. Couples will eventually seek you out for this unique style as it will be recognisable as yours alone.

Use the images here as inspiration. Look for recurring themes throughout that are traits of excellent photographers. Perhaps the most obvious and common of these are the lack of eye contact between the couple and the camera, and how gentle it is when couples touch or kiss. There are many more which I hope you will easily be able to spot as your knowledge increases.

Russ Pullen

Most locations that the bride chooses for her preparations will have a bed which acts as a great prop. If she is willing, ask her to lie down but be very careful she does not crease her veil. It may be prudent to take the shot before she has it put on or after the ceremony. Here Russ has slightly concealed the bride's face, lending intrigue to the image.

John and Joseph

Taken on a firm bed, the bride has been asked to lie across it, with her right side lit by a large window giving soft light. Careful consideration has been given to her hand and arm positions to ensure they are elegant and soft. Notice how she has her fingers folded on the hand that touches her cheek. The shot is finessed by having her cross her ankles to show the style of her shoes.

Romeo Alberti

Romeo has given careful consideration to this image. The edge of the bed creates a leading line towards the bride. Both lamps have been turned on, with the shade seam to the back. The veil has hidden the bride's shoulders which can look a little awkward in positions like this. Her legs are angled towards Romeo, giving shape to the dress.

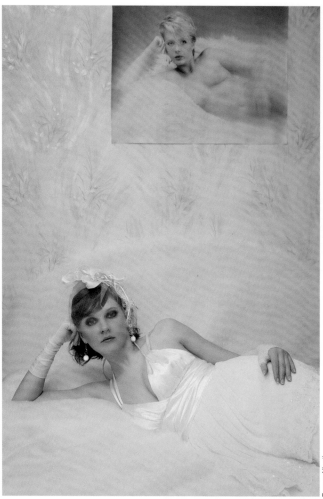

Romeo Alberti

The light in this shot is very soft and was created by bounced flash. The bride has adopted a pose that plays on the image above the bed by almost copying it. She is positioned with her legs closer to the camera and her hand very softly resting on her thigh. Art is a source of inspiration in general so it is worth investing in plenty of books.

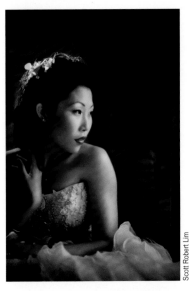

Scott has asked the bride to sit on a chair and turn her chest towards the main light source. A secondary light positioned above and behind is falling on her hair. You could choose to use a table lamp, flash or video light for this. The bride is leaning forward and to add elegance has her right hand very gently positioned to the side of her neck.

Scott Robert Lim

Sitting on the edge of the bed the bride has been asked to look down towards the floor whilst just touching her beads. Look at how her wrist curves around with her fingers to create a 'C' shape. The veil has again been placed over the bride's shoulders. This position allows us to see the detail in the bride's gloves and also her earrings. The wall provides a strong, rich background colour that contrasts well with the warm light created by the table lamp. A video light was used to light the bride's face.

Romeo Alberti

A beautiful portrait of the bride. Great care has been taken to shoot at an angle so she does not look awkward. Practise this with a friend until you get it right. This image has been finessed by great positioning of the hands and the delicacy of their position, being intertwined. The image is further refined by having the bride look down and not at the camera. The angle ensures that her mouth still remains visible.

Eugene Alexandrov

This is the same bride as seen lying on the bed on page 98. This time Romeo has asked her to bring her veil up over her head which achieves two important aims: the detail on the veil is seen clearly and it also frames her face beautifully. It has been pulled backwards a little to give it body, and the bouquet brings the components together.

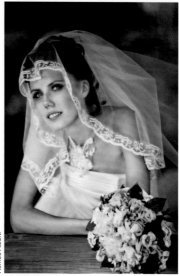

Romeo Alberti

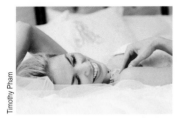

Timothy Pham

Tim has positioned the bride and then moved to his left, ensuring that the bride did not follow him with her head or eyes. If she had, wrinkles would have appeared on her forehead which is a common fault and an important point to remember.

This is a beauty shot taken during the bridal preparations. The main focus is on the bride's beautiful eyes and the make-up applied. The bride's nose is contained within her cheek ensuring that it does not appear large.

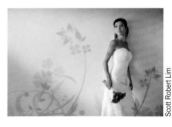

Scott Robert Lim

Ela I Michal Barteczko

This image shows the delicate beauty of the bride with her fair hair and blue eyes. The left side of her hair has been allowed to fall over her eye with her head tilted slightly towards the highest shoulder. Her characteristic pearls complete the image.

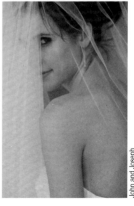

John and Joseph

Covering the bride with her veil can add a natural softness to the image. Here John and Joseph have placed it purposely to fall down the side of her nose, allowing the bride's eye to be the focal point of the image. If they had included all of the bride's head the composition would have been ruined. It is always worth looking to see if the way you crop an image has a large impact on it. It often does, but still strive to visualise and achieve the image at the time of capture.

Our repertoire of shots should include many that can be taken in simple environments yet still look stunning. This is a perfect example of such a shot, which could be taken in any room with plain walls. Sybrand has simply asked the bride to lean against the wall, being careful to separate her arms from her waist whilst clutching the bouquet. If natural light is not available then well balanced flash works very well.

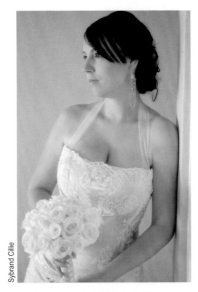

Sybrand Cillie

Another shot by Sybrand to show how just a little alteration, taking only moments, creates another image to give variety. This time the bride's chest is angled away from the camera and her head turned towards it. The bride has been asked to look past the camera and have her arm dangle naturally. Natural light from a window behind the photographer has really brought out the colour of the bride's eyes.

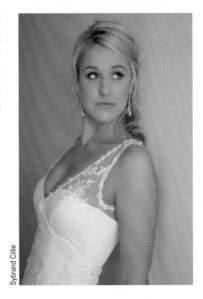

Sybrand Cillie

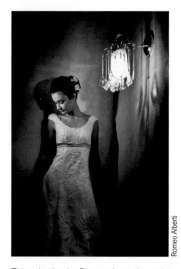
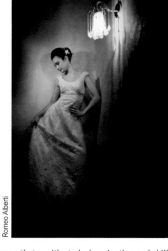

Romeo Alberti

Romeo Alberti

This selection by Romeo shows the variety of images that - with study, imagination and skill - can be found in basic locations. In the upper left corner the bride has adopted a simple pose by looking down and having her hips slightly weighted towards her right leg. In the next image this has been accentuated by the bride holding her dress and placing her hand on her hip. In the bottom right images rose petals have been thrown and a slow shutter speed used.

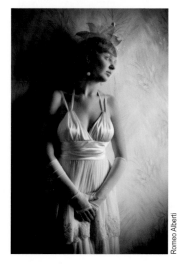
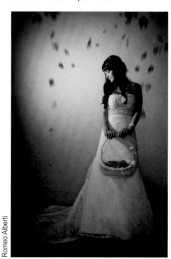

Romeo Alberti

Romeo Alberti

This is a shot that could be very ordinary but has been transformed by good posing. As you look through these galleries you will notice how rarely the bride is actually looking at the camera. This is one aspect that separates the posing skills of an excellent photographer from those of the aspiring photographer. It is knowing when an image will benefit from eye contact and when it will not. Note how the bride just touches the wall and does not have her hand fully on it. Her right leg is positioned to add body and form to her dress.

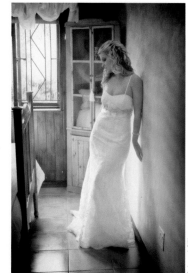

Sybrand Cillie

In this image Immi have chosen to photograph the bride from behind to show her back. She has then be asked to turn around and look at the floor. You have to be careful when turning the head to avoid any unsightly creases in the neck. Note how the bride is standing away from the wall and leans back into it, supporting herself with her left arm. The right arm creates a 'C' shape with her hand resting on her thigh. ▼

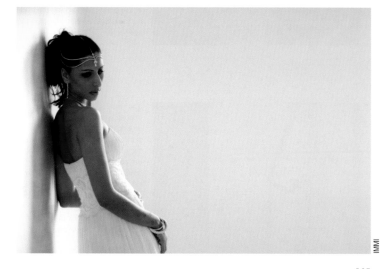

IMMI

105

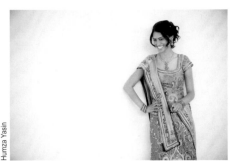

Humza Yasin

At most venues you can find a plain wall to photograph against. This will focus all the attention onto the bride. Here Humza has taken a playful image by asking the bride to have one hand on her hip and then joking with her. It is a great technique to inject your personality into the shoot, resulting in natural expressions.

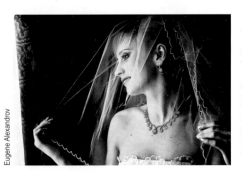

Eugene Alexandrov

Dark rooms can provide excellent opportunities for portraits. Here Eugene has asked the bride to stand at a slight angle to him and turn her tilted head to the window. By very gently holding the veil and placing it over her face, great refinement has been achieved. The very top of the dress has also been included. You can control the amount of light reaching the bride by partially shutting the curtains or blinds.

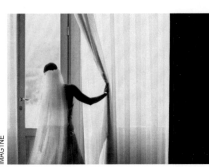

iMAG1NE

You may notice that there are probably a greater number of monochrome images in this section than any other. I believe that monochrome can help remove distractions when shooting in homes or hotels. Another way to avoid clutter is not to include the floor or any surfaces in the preparation images, as seen here. The bride pulls back the curtain to look out of the window.

Another example of a simple yet beautiful portrait of the bride. The shutters were closed to block off excessive light and the bride asked to sit on the window ledge. Her body is towards the camera but her knees pointed away slightly. A vignette has been added in post-production to draw the eye into the bride.

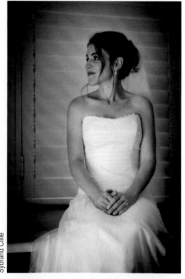

Sybrand Cillie

A lot of thought has been given to the composition here. The bride has been asked to place her leg on a stool to elevate it a little. Her shawl has been wrapped around her arms and her hands positioned very delicately with one finger gently resting on her other hand. The bride is leaning forward slightly and Olga has taken care to place her within the frame in the background but slightly off-centre. The bride's head is angled slightly and the eyes focussed directly towards the camera.

Andriyash Olga

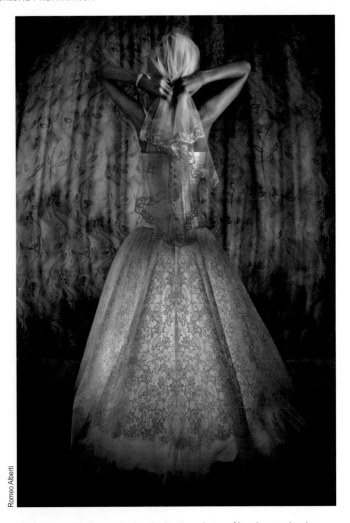

Romeo Alberti

The bride was asked to gently place her hands on the top of her chest, to close her eyes and to lift her chin. A video light was shone on her and the photographer asked her to imagine it was the warmth of the sun falling on her. This resulted in her beautiful and natural smile. The bouquet acts as a prop and enough light falls on her dress to show the texture.

A classic image that the bride and groom will love. Experiment with the pose you use as you have a variety of options available to you as shown here. This image shows the back of the dress perfectly and the bride veil.

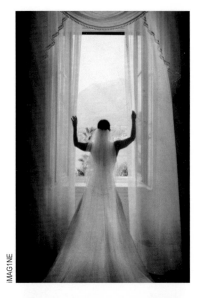

iMAG1NE

Try to look for less obvious images to capture. Here Humza wished to record the detail and bow on the back of the bride's dress. He placed her near this large window at an angle to him. The bouquet is simply a prop here and gave the bride something to do with her hands. Exposure would have been taken from the window to avoid blowing them out completely, and supplementary lighting used to light the bride.

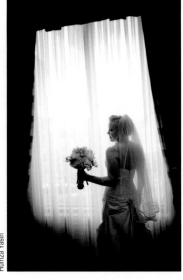

Humza Yasin

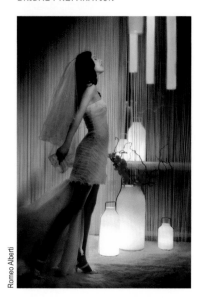

Romeo Alberti

If a bride wears a short dress then you need to capture the beauty and grace of her legs. Romeo asked the bride to take the veil in her fingertips, lean back and extend her right leg backwards as though she was flying. This has created a beautiful reverse 'C' shape which shows off her waist perfectly. To complement the warm tungsten light a flash has been used on low power and with barn doors (you could also try zooming the flash head). The pink flowers finish the image, adding a lovely splash of colour.

By now you can see how beneficial having a video light is and the opportunities it provides. Here is another example. The bride was positioned by the table and asked "What is in the boxes?" This caused her to look down and the moment was captured.

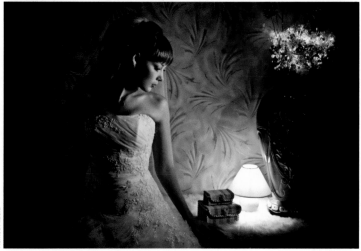

Romeo Alberti

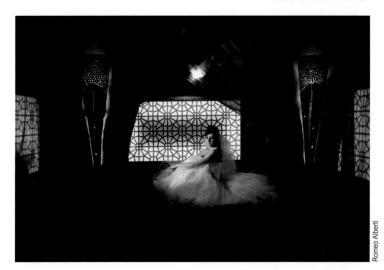

Romeo Alberti

Couples choose their wedding venue for many reasons but one is because they love the details and atmosphere. It is therefore our responsibility to capture as many of these details as possible. These may be as miniatures or as here where the design-led lamps are a focal point of the room. Exposure was based on the lamps to show their detail and a video light used to light the bride.

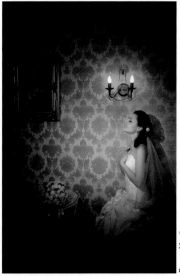

The bride was asked to gently place her hands on the top of her chest, to close her eyes and to lift her chin. A video light was shone on her and the photographer asked her to imagine it was the warmth of the sun falling on her. This resulted in her beautiful and natural smile. The bouquet acts as a prop and enough light falls on her dress to show the texture.

Romeo Alberti

111

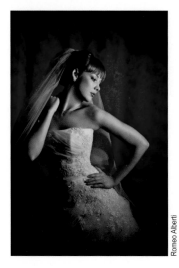

Romeo Alberti

Romeo Alberti

All the images on this page have a common theme - they have all been taken in low light situations or where the photographer has minimised the light intentionally. Brides love shots that include mirrors so seek inventive ways to incorporate them into your work. Instead of zooming in close why not pose the bride within the mirror? Look for any natural light sources you can use.

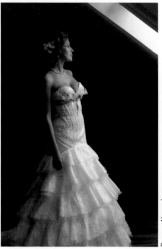

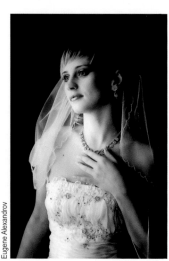

Eugene Alexandrov

Eugene Alexandrov

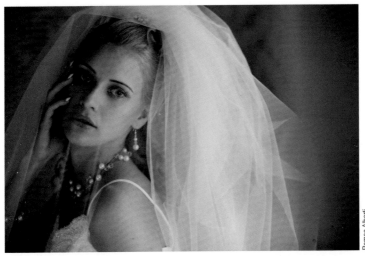

Romeo Alberti

The pose you select should match the mood and personality of your subject. In the image above the bride was feeling a little nervous before the wedding so an elegant pose with careful placement of the hand was selected. The bride below was really excited and full of energy and personality so a classical and beautiful pose showing this was chosen.

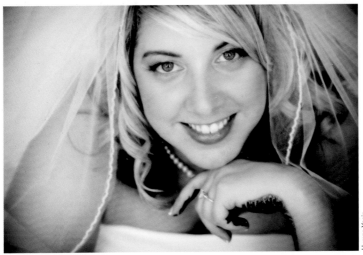

Humza Yasin

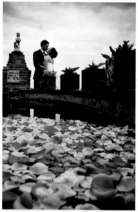

Kevin Tran

The flowers and wall are a perfect leading line to this couple. If you spot colour like this then try to find a way to utilise it within your work. Having a good sky also helps.

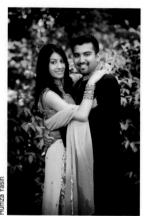

Humza Yasin

This image can be taken in any garden. Simply find the good light and ask the couple to embrace hip to hip and place his arms around her waist and hers around his neck.

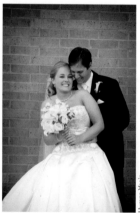

Humza Yasin

An example of a pose that can be shot anywhere. Humza has again used his personality here to engage the couple and create natural expressions.

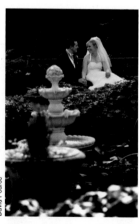

David Pearce

This was taken on a very sunny day so backlit. I wanted a natural loving shot of the couple to asked them to sit on the bench, hold hands and simply chat.

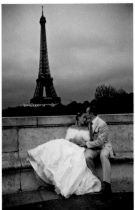

Kevin Tran

It goes without saying that if there are national icons near you, you should use them. The groom is softly bringing the bride's head towards him to gently kiss her.

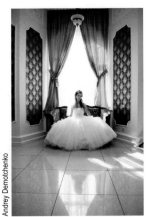

Andrey Demotchenko

You will often find reflections on floors such as marble, so get into a low position for the best effect. Here Andrey wished to show the symmetry and size of the bride's dress.

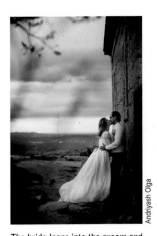

Andriyash Olga

The bride leans into the groom and places her hands on his chest. Her head is tilted, allowing their noses to touch and creating an imaginary diagonal line between their eyes.

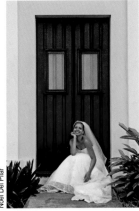

Noel Del Pilar

Doorways are a common theme as they frame people naturally. If the floor is clean, ask your bride to sit down and perhaps lean forward and rest her chin on her hand.

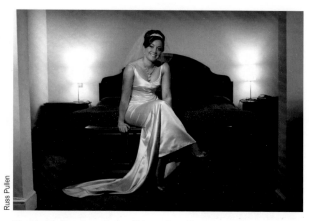

Russ Pullen

Most hotels have large beds which can be utilised as excellent props. Both lights have been switched on, breaking up the plain wall. The bride sits with her legs crossed to accentuate her legs. By looking at the shadows you can see that a video light or flash has been used. The train of her dress has been arranged to show its extent.

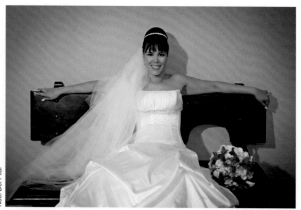

Noel Del Pilar

Noel wished to use this fantastic chair so asked the bride to take a seat on it and extend her arms. By having the veil flow down one side he has broken the symmetry and incorporated a diagonal aspect in the frame. The bouquet adds a final touch. If you find that there is not a lot of colour in an image but there are tones or shadows then it is worth converting to black and white to see how well it works.

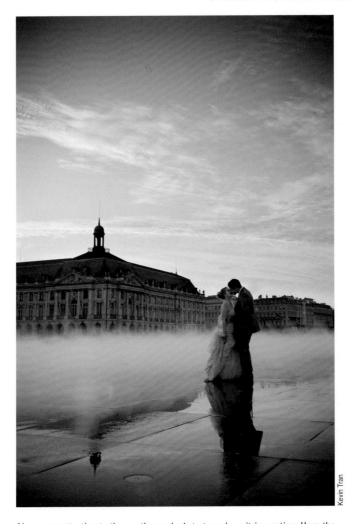

Kevin Tran

Always pay attention to the weather and what atmosphere it is creating. Here the ground fog has meant that tourists have dispersed leaving an open view of the building, whilst the rain has allowed the couple's reflection to be strong. This is a perfect example of when you can shoot at a wide angle as the couple are far enough away and not close enough to the edge of the frame to be distorted.

Romeo Alberti

The bride was asked to smell the flower from a short distance, while placing her fingertips on the bottom of her cheek. Her hair was arranged to the side. Take note of the composition.

Romeo Alberti

Romeo asked the bride to stand by a window and used a reflector. He simply whispered how beautiful she looked and got this lovely smile in return. Communication skills have a great influence on expression.

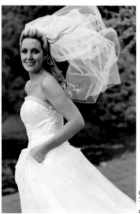

David Pearce

This was taken when I first started shooting weddings. I asked the bride to walk whilst I followed by the side. When the wind caught her veil I called, causing her to smile.

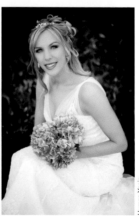

Humza Yasin

Most gardens have a chair. Invite your bride to sit at 45° to you, turn towards you and lean forward. The bouquet adds colour, creating a lovely image.

Andrey had been walking in the park and noticed the big pool on the road and a beautifully inclined tree. She told the bride and groom to stand under the tree and to embrace each other, with the groom kissing his bride's neck. Andrey wanted to make a romantic picture as if the newlyweds were standing on the bank of a lake, under the old tree which gently protects them from bad luck. Andrey asked her assistant to stand near the newlyweds and shine a video light on them. This resulted in a warm colour on their faces and the green colour of leaves and grass could become more saturated. Andrey sat on the grass 6 metres away to enable her to be low down, which enhances any reflections.

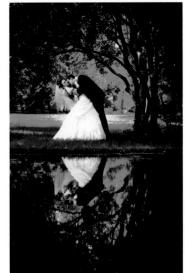

Andrey Demotchenko

In Autumn I love to make use of nature's colours as much as possible. Sometimes they dominate the image and at other times are a subtle addition to an image. Here, Kerry has captured the couple very naturally. You can literally see the love in the bride's eyes as she looks back at her husband. The branches of the tree lead us to the couple. I love the way the bride is holding his hand ever so gently and has her head tilted towards her higher shoulder. The location has also been chosen for the perfect soft light.

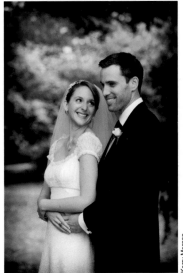

Kerry Morgan

119

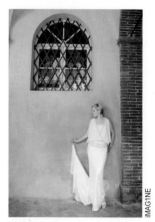

Walls can offer great opportunities to inject colour into your work. Look at the composition, the leg positions, the bride's foot and how she holds the train of the dress.

Simplicity, elegance and beauty are all found in this image. The bride's arms have been brought forward to bring them away from her side to show off her waist line.

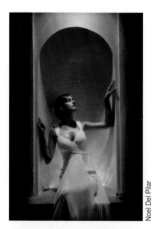

Many photographers might have walked passed this alcove. Noel spotted it though, and asked the bride to sit within, lean to one side and place her hands on the walls.

This classic pose flatters every figure. Bring the flowers up towards the neck if you need to cover a bust for modesty. The leaves wrap around and make a lovely background.

Humza Yasin

Jose Del Valle

Light is the basis of all photography. It is essential that you only take images in good light or created light. It is a fundamental skill of a photographer to "see" light.

A little bounced flash was used here to create the soft light. It is a detail shot of the bouquet but with enough depth of field

Noel Del Pilar

William G

This pose really lends itself to Indian brides. It shows off all the bangles, sari and head pieces. Having the bride look out of the frame adds to the image.

Selective focussing has thrown the object into the foreground out of focus and added depth to the image by creating a different layer.

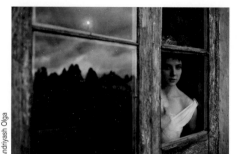

Andriyash Olga

You often see an image of a bride looking out of the window, taken from within the room. Here Olga has reversed it and captured the bride doing this but from the outside. The window frame is a strong leading line and the reflections really add to the image.

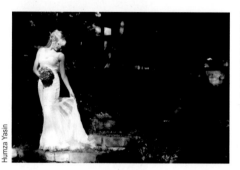

Humza Yasin

Humza has asked the bride to stand in the direct sunlight in the garden but to hold her dress gently and look down towards it. Her arms are separated from her body and her left leg is in front of the right. By exposing for the dress a lot of the garden has been darkened, creating a natural vignette.

Karen Bridges

There are many ways you can demonstrate the connection between bride and groom. Here Karen has asked the groom to stand on the first step of a fire escape whilst the bride is on a lower section. She holds both rails and looks up towards him. Abstract images like this look fantastic and will help separate you from other photographers if executed well and with style. Use your imagination.

If you are able to adopt a high viewpoint then take the opportunity to do so. We are so accustomed to seeing the world at eye level that this gives great visual impact. Mario has positioned the bride at the end of the sofa and asked her to place her arms on its arms. Note how the arm closest to the camera is covering the other wrist. The bride is leaning forward and looking out of the window. The dress shows all of its body.

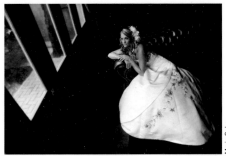

Mario Sales

This image shows great artistry and ability from the photographer. To create an image like this ask your bride to pretend she is a flamenco dancer and to turn with her hand in the air so her dress flows off the ground. Shoot from a low perspective and wait for her to be looking to the side. It may need several attempts to get right.

Scott Robert Lim

123

Russ Pullen

Create motion by asking your bride to throw her veil in the air. Notice the bride's leg positions. Russ has taken a low position to really emphasise the motion and add drama to the image.

William G

Look-out for different angles to use which can isolate your subject and eliminate any distractions. William wanted to use the magnificent lines on the piano so asked his bride to sit and hold her flower.

Russ Pullen

The bride has been asked to stand with her back to the wall and look down to her shoulder. The front door has been opened to bathe her in good light.

Alexandr Arkhangorodskiy

Alex noticed this amazing curtain hanging from the ceiling. He took a high position and asked the bride to step forward, raise her arms and push it forward.

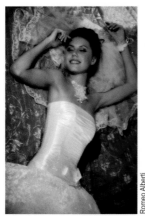

Romeo Alberti

When positioning a bride on a bed pay attention to the way she is supported. It is easy to distort body features by applying pressure if leaning on a hand for example.

Romeo Alberti

The bride could easily have distorted her chin but instead Romeo has asked her to bring her hand up to her face in this soft manner.

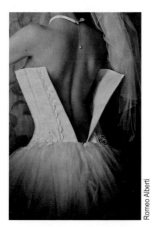

Romeo Alberti

If the bride is proud of her back then why not capture that as well? Try practising with a model first so you can show the bride the look you wish to achieve.

Adrian Downing

Adrian has placed the veil over the bride's shoulder and used the flowers as a focal point of the image. She is standing tall and has her chin slightly extended.

Yervant

Yervant is a master at posing and is copied prolifically. A lit red wall, an arm on the hip, the bride's right leg crossed over and bent, whilst the train is placed to the right and the bride laughs.

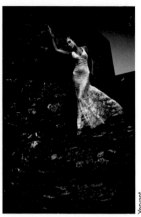

Yervant

Often the decision to convert an image to black and white is made due to tone and texture within the shot. Here the bride's pose contrasts with the irregular shape of the stones, yet they seem as one.

Yervant

How much does this image tell you about the bride? Yervant has asked her to stand at an angle to him, to tilt her head and slightly part her lips. We do not need to see her eyes.

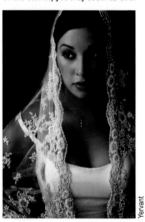

Yervant

We can clearly see the bride's elegant beauty in this image. The veil frames her face and shows its detail. It has been taken from above and lit from camera left.

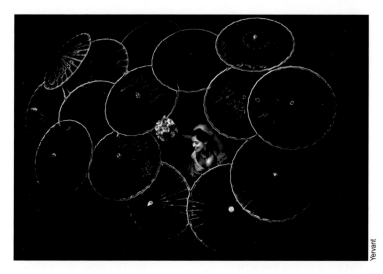

▲ What can I possibly say about this stunning image by Yervant? It is simply amazing.

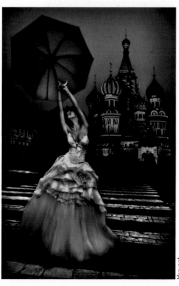

Great architecture deserves exquisite posing and imagery. Yervant has achieved this perfectly. The crossing leads you from the bride to the building whilst the side lighting highlights the details in the dress. The bride has created shape in her body, pushing her hips to one side and extending her arms in that direction.

Yervant

Emma Hughes

The simplest windows can create beautiful images. The backlighting means you can see the shape of the bride's legs as the dress flows to the floor. The vignette and texture has finished the image perfectly.

Joanne Dunn

There is a timeless elegance in this shot. Taken from a lower shooting position the bride is framed perfectly within the semi-circle on the ceiling and between the fireplace and mirror.

Joanne Dunn

On this occasion Joanne has chosen to shoot from an angle and draw attention to the bride's wonderful shoes. Her hands are perfectly positioned.

Du Wayne Denton

The bride has been asked to look out onto the garden, for a timeless portrait reminiscent of a painting. The veranda's frame and the door shutters contain the bride.

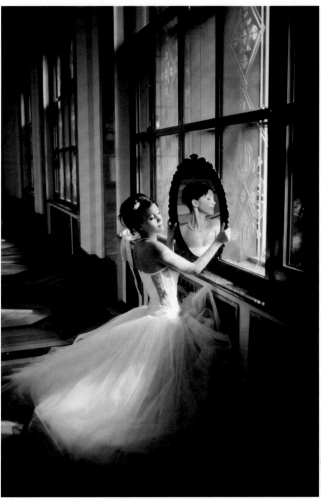

Andriyash Olga

Taken in the hallway of a grand house Olga has purposely taken the mirror to use as a prop. The sun shone through the window at such an angle to light the bride's face and then reflect down on to her dress. Look carefully and you can see the bride's reflection on the first panel . The image has depth, created by shooting at an angle to include the remainder of the room. In this situation you could also zoom in to take a selection of close-up images with and without the mirror, providing variety and choice.

DQ Studios

By shooting inside during the late afternoon or early evening you will often find pockets of light. Here Dave and Quin have made full use of such light emanating from a window. Whereas less artistic photographers may have included all the bride's face, they have elected not to, adding mystique to the shot. It is finished by including the light shining through the vertical panel of windows.

I love shooting indoors where I have full control of the light. This situation presents many choices. Mark could have placed the bride in the centre and have her face him, or do as he has here and had her half sitting and half lying. By offsetting her face he has broken the symmetry. There are lots of visual triangles in this shot, which are something we should strive to create, as a triangle is a positive shape within an image.

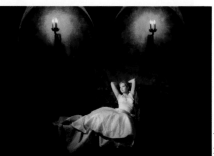

Unique Images

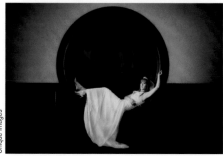

Unique Images

Any interesting item you can find that the bride can pose by, in, or on, is of use to you. It may prove at times to be a little awkward for the bride but the resulting image can be sensational. You need to be careful not to make the pose cheesy and it has to be lit well. Concentrate on the bride's leg positions and ankles as Mark has done here. The expression should match the pose.

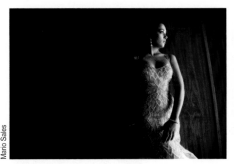

Mario Sales

A wood-panelled wall can provide sufficient interest to make a good shot. As the light falls away from the window the image naturally darkens. Mario has positioned the bride in the optimum light: any closer to the window and it would have been too much, causing harsher fall off and perhaps making the left side of her dress too dark to see.

The use of negative space is very powerful within an image and is one factor separating a pro from an amateur, who always has the subject in the centre of the image. I love the tones here, varying from the beige wall to the black background and the brilliant white of the bride's dress.

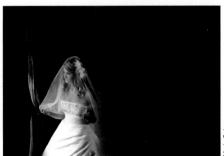

Mario Sales

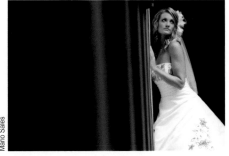

Mario Sales

This type of shot is regularly taken but very hard to execute well. All too often it appears that the bride is holding up and supporting a wall instead of posing against it. Composing the image in such a way that the wall leads you into the bride, with only one hand visible (and only touching the wall very gently) is one way to avoid this. It was taken in very low light and lit by one skylight.

Scott Robert Lim

By placing the bride's head in the ray of light it is perfectly framed. Her purple dress contrasts very well with the green wall and she is in a confident pose.

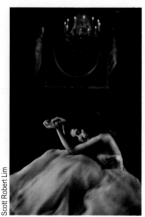

Scott Robert Lim

This is a very delicate image of the bride. Take note of her hand position and the way she rests her chin on her arm. There is a lot of elegance here.

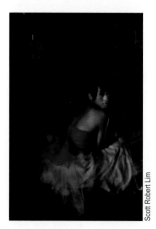

Scott Robert Lim

The bride has been asked to sit on the staircase so we can see the detail in her dress. She looks at the camera without her nose "breaking" through her cheeks.

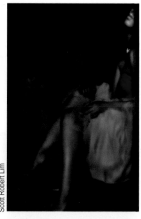

Scott Robert Lim

This image cleverly focuses on the bride's shoes, dress and bodice. Her legs have been placed at differing heights and she has been asked to look up towards the light source.

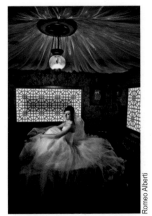

Romeo Alberti

Charlotte Geary

This shot is similar to the one shown earlier, but with a closer crop on the bride to show the extent of her dress. Its train is placed over the table she is seated on.

Careful attention has been paid to show the train and veil of the dress with a grandiose location chosen to match. We can also see the bride's bouquet and her face turned towards her shoulder.

Humza Yasin

Noel Del Pilar

You can create pools of light such as this by making a cone with some card to put over your flash. Experiment at home to develop all sorts of shapes and looks.

Taken at night, there was hardly any available light so Noel had to rely on the downlights in the entrance.. By asking the bride to look up, the light fills her eyes and face.

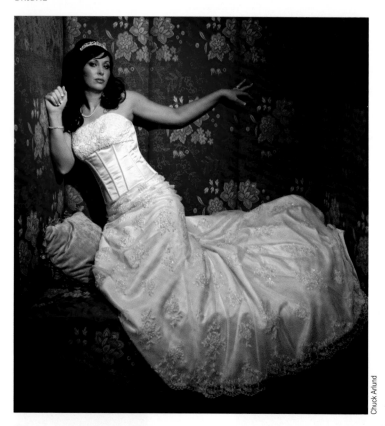

Chuck Arlund

When you are shooting in a venue with grand furniture like this you have to use it. Here Chuck drew on his experience of shooting fashion to create a pose that is very well suited to the bride but is actually all about her dress. This is probably a little awkward for a bride to hold for too long so set the shot up in relation to your lighting and then bring the bride in. Visualise the placement of the hands so you can articulate your thoughts to the bride.

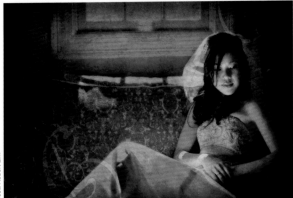

Scott Robert Lim

Scott has used a texture very successfully to add a softness which underlines the bride's beauty. This image looks great as the bride's leg position is creating a lovely triangle. Her hips are turned inwards causing her knees to point towards the upper corner of the chair. She has then placed the lower part of her legs towards the floor. Her arms are away from the body and shadow has been used in a flattering way.

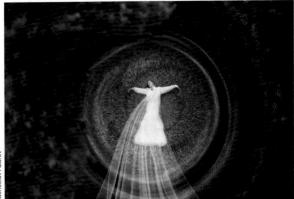

Viacheslav Azarov

This is an example of when a digital effect can be powerful. Shot from above, it is almost as if the bride and groom have morphed into one. The swirl tool has been used to create the circle effect, but use this very sparingly and only on an image which can benefit from it. This may be just one shot a year or even none. It works here as the shot was taken from above.

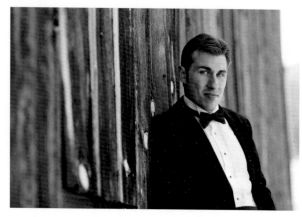

Steve Zdawczynski

A classic shot of a groom. Up against a wall and shooting along the wall with a shallow depth of field. Due to the crop the position of the hands is not important but the position of the arms is. You can see that the groom's right arm is coming forward from the elbow instead of hanging down by his side.

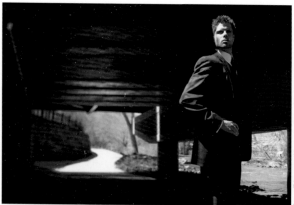

Steve Zdawczynski

Steve was looking for shade, but positioned the groom on the edge of the sun and used it like a fashion light. Dark shade provides a lot of contrast to make him pop from the background. His body is breaking the rules and pointing out of the frame, but his head is turned, and the light on his face is into the frame. Compositionally there is the classic winding path lit in the background.

Scott Robert Lim

When shooting inside, squint your eyes as David Beckstead suggests, to see where the light is. You will then be able to place your groom in that spot and create some lovely images. Remember to move around and see the variations that can be achieved. Use different angles and lenses for different looks.

Scott Robert Lim

You can really emphasise the groom by zooming-in on him (do not use a wide angle as this will distort him) and including the groomsmen in the background out of focus. Cigars always look good if they have them.

David Pearce

I wanted to take a shot of the groom looking out of the window and used the darkness of the room to focus all attention onto the groom. You can see that he is a good distance from the window to avoid too strong a contrast between the lit side of his face and the dark side. It is really important to be aware of small details such as this.

Russ Pullen

Another great example of using a pocket of light to place your subject in. The image is enhanced by the ledge acting as a leading line. It has a further purpose of helping make the triangle of light.

Joanne Dunn

Joanne has drawn attention to the groom in this image by waiting for the bride's veil to blow and cover her face. She has got in quite close to the couple in order to allow the veil to flow out of the frame.

Steve Zdawczynski

This is a well-spotted reflection by Steve Z. It is only by constantly being aware of your surroundings that you begin to notice items, such as this metal sheet, which you can use to reflect an image of someone. The groom is standing with his shoulder against the wooden building and has been asked to place his right heel on a rock to elevate it. Notice the way his hand is placed in his pocket.

Humza Yasin

This shot works on many levels. I particularly like the way the groom is squatting down and in perfect light whilst the groomsmen are all standing and chatting to one another. The groomsmen are also in a far darker area and out of focus, pulling our attention to the groom. Humza has taken time to ensure the groom's hands are positioned well, which is often overlooked when photographing men.

Romeo Alberti

This image is about the bride and groom's flowers. It is a very posed image and therefore vitally important to ensure the groom's expression is correct. A reflector was used to throw a little light onto the groom.

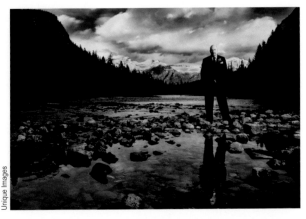

Unique Images

It is essential to do this with a groom who is fully compliant and willing to have such a shot. Not only do we have a perfectly composed reflection, but the tree line leads us to the back of the image and the mountains. The image has been slightly under-exposed to bring out the sky and an off-camera flash used to expose the groom correctly.

Nathan Bridges

During a pre-wedding visit to the location, Nathan noticed this wall with the mansion behind. The groomsmen were all game and agreed to climb up and stand on the wall. The image is made all the more interesting by the person on the right hand side leaving his hands out of his pockets, breaking the symmetry.

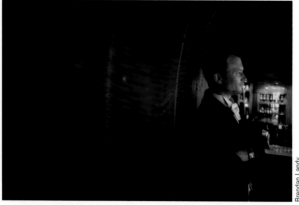

Brendan Landy

It was Brendan's intention to create negative space to lead the viewer's eye directly to the groom. Shot with the album design in mind, he was looking for a strong full page lead image, that had warm colours but little distraction from the main subject. The lighting is from a window on the right as you look at the image, and a little tungsten lighting on the background.

Romeo Alberti

Lit by daylight and a reflector, the groom was asked to adopt a confident pose - causing him to clench his fist lightly and then look directly into the camera.

Russ Pullen

A relatively standard image can be transformed by simple yet highly effective actions. The groom was placed in a pocket of light and the bride asked to touch the underneath of his chin very gently with her fingertips. The groom needs to be looking into the camera for this shot to work well.

Romeo Alberti

You can create this type of image by asking the groom to stand against a wall, cross his arms and look away from the camera. If you can move a lamp and use the shadow it creates effectively then do so (assuming of course that the lamp is not of great value or importance).

Du Wayne Denton

A classic portrait that would not look out of place in a top men's magazine. The groom has been asked to stand tall and place his hand within his pockets. Standing at an angle to the camera he faces towards the light. The angle chosen by Du Wayne allows us to see all of the wall pillars.

Humza Yasin

If you stay observant you can find locations to take shots in virtually any room. Here Humza has asked the groom to get into a low position so he can avoid background distractions. The groom looks out towards the window, which gives refinement to the image. The shot is enhanced by the groom's leg positions, with one knee high and forward and the other lower to the ground. This has ensured that when he places his arms onto his legs they have fallen naturally into a diagonal position.

A strong portrait of the groom. By now you will have noticed a number of consistencies amongst the poses. One of the most common characteristics is the lack of eye contact between the subjects and the camera. When we start our photography careers we tend always to ask the subjects to look at us and "smile". I hope that by now you have realised that this does not have to be the case and in fact is almost a rare occurrence in posed wedding photography. The images can be a lot stronger with a lack of eye contact.

Kristin Reimer

To create this relaxed portrait of the groom, Du Wayne has been careful not to allow the waistcoat to ride up the groom's chest. This can be especially problematic with larger men, in which case have them sit on the edge of the chair and pull the waistcoat down. Here the groom could happily sit back, but the bottom of his waistcoat has still been obscured by crossing his legs which brings his knee up.

Du Wayne Denton

Kris McElligott

When everyone has left the church it can be a fantastic idea to take the bride and groom back inside for a quick portrait session. Kris has done exactly that with this image. It is an especially useful location if the ceremony is in the early afternoon during summer. By going back inside you avoid the harsh sunlight, shadows and generally unflattering light. You can be in control and use off-camera flash to contrast with the warm interior tones of the church.

If the groom is happy with his physique then this type of shot is always appreciated by his bride. Try to plan time to visit the groom as well as the bride before the wedding. It will break the ice and allow you time to capture some great shots that will sell. We have all seen many images of cufflinks being attended to but very rarely the groom actually putting on his shirt. Play around and be inventive.

Romeo Alberti

Steve Zdawczynski

Steve is always on the look-out for unique shadow patterns. Often we avoid those that fall on the subject but sometimes they can be used for artistic and creative effect. This was shot under a stairwell.

Unique Images

A straightforward shot that was made special by off-camera flash. Mark was able to expose the window to retain detail and then use off-camera flash to light the groom.

iMAG1NE

This shot demonstrates perfectly how good positioning of the hands makes such a real difference to the final image.

IMMI

A beautifully delicate low-key image. The light is coming from the right hand side, shaping the bride's face superbly and falling onto the groom. It is then reflecting from his forehead to add a little light onto the unlit side of the bride's face. She is resting gently against his temple area as he looks down and kisses her on the neck.

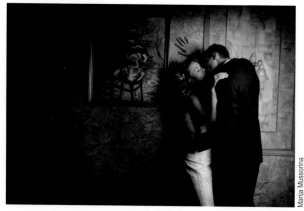

Marija Mussorina

The bride's nose is generally more pleasing to the eye than the groom's, so if possible ensure that you position the bride so hers is camera side. This is a strong pose with the groom's hand against the wall. It has been lit by off-camera flash with a zoomed head to create a pool of light.

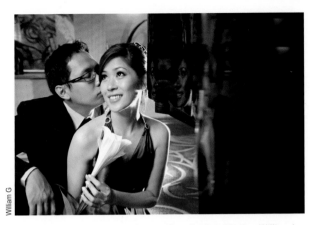

William G

This is the same bride as seen in a previous shot but this time William has brought the groom into the shot and himself gone to floor level. The bride is in a similar position to before but the groom is kneeling down to kiss her. The multiple reflections really add to this shot.

Jose Del Valle

This image has great depth. Starting with the vase in the foreground we are drawn towards the bride and groom who are in an embrace. Your eye is then taken beyond the couple to the desk lamps and into the library in the background.

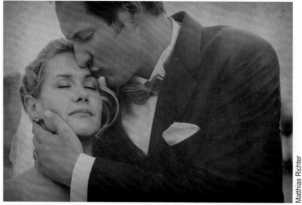

Matthias Richter

It is not always easy to get a shot of a powerful man being delicate but Matthias has achieved that here by having the bride close her eyes. The groom is bringing the bride's face towards him, but without pressure that would result in her cheek lines being altered.

Chenin Boutwell

Chenin has used the groom's shoulder as a prop for the bride to lean on. The bride's nose in contained within her cheek, she has soft lips and her fascinator follows the curve of her eyes and does not extend to her nose. If the groom had looked towards the bride it would have looked awkward.

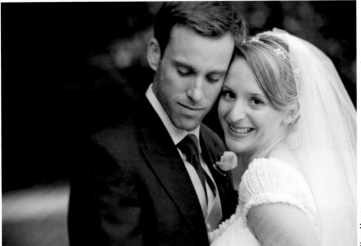

Kerry Morgan

▲ Kerry has purposely positioned the couple off-centre to avoid the "bulls eye" shot and create some negative space. This is something that non-photographers rarely do, so separates your work by its excellent composition. If the groom was looking at the camera the image would not be as effective. Having him look down adds class.

By contrast, this image shows that you can place the couple in a "bulls eye" position and still have a excellent shot. By shooting through foliage with a shallow depth of field, a natural border has been created around the couple which draws your attention to them. Look for nature around you to achieve effects such as this.

Emma Hughes

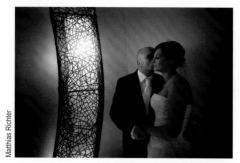

Matthias Richter

Often in reception venues you will find interesting lights or ornaments which can be used within your compositions. Be careful with your exposure when shooting lights so as not to lose the detail of them.

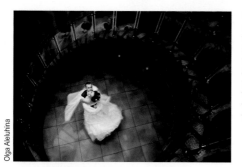

Olga Aleluhina

The bride and groom have been placed slightly off-centre within the oval created by the spiral staircase. The colour contrasts very well with the bride's dress and by shooting from a high viewpoint Olga has drawn us into the couple. It was important that the bride and groom looked up at the camera.

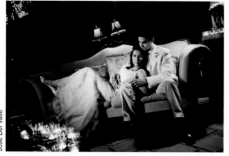

Jose Del Valle

I like to take the bride and groom for another portrait session after the meal has finished and before the dancing begins. They are often more relaxed after a glass of champagne and if the light has dropped you get a totally different look to your images. If you notice candles in the vicinity then ask staff to light them for you. The bride has angled her chest to the camera, ensuring she looks comfortable.

If you can, try to incorporate some aspect of the season of the year into your coverage. Fujita chose to place the bride and groom back to back, creating a less obvious pose.

Tsutomu Fujita

The window was the only light source in this cellar. Andrey asked the newlyweds to imagine they were there alone and to show their behaviour in such a situation. She asked the bride to turn her head towards the light, showing her neck, in order to make her look more innocent. The groom was told to gently kiss her neck and embrace her waist.

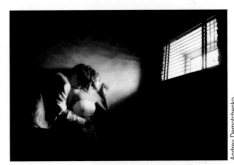

Andrey Demotchenko

If you use a video light or off-camera flash then you can use it for artistic effect by creating shadows. Practise this and see what difference it makes to the shadows, depending on how far you are from the object casting the shadow. Can you create soft-edged and hard-edged shadows by moving closer or further away?

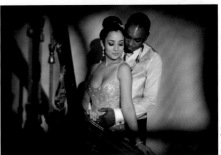

Mario Sales

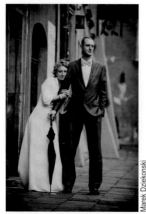

Marek Dziekonski

If you have a tall groom then you do not have to hide it. The bride clinging to his arm is maybe a natural and instinctive action. The umbrella adds to the groom's stance.

Jean-Pierre Uys

Hotel bars often have a lot of money and thought given to their design, making ideal "sets" for you to work in. Notice the movie star-style seating position of the groom.

Elena Bocharnikova

Dusk can be very atmospheric and Elena has created a contrast between the sky and the bride's dress. I particularly like the casual nature of the groom's stance.

Marek Dziekonski

An athletic groom can really make your images stand out. If he is willing then ask him to stand on walls, but conform to your country's health and safety regulations!

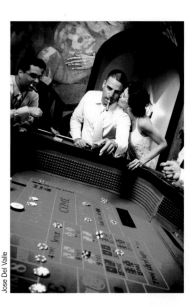

Jose Del Valle

If the bride and groom have hired a [...] for the event it is crucial to get some really good images of it. Watch movies and see how the actors portray themselves in certain situations, for inspiration that you can draw upon. You want shots like this to be cool and by having the cigar, the hand throwing the dice and the bride leaning over for a kiss, you have all the elements needed for a fantastic image.

Dusk is an ideal time to photograph. It provides a different type of light but be careful to shoot when there is still some colour in the sky. By using off-camera flash and a correct white balance, Kerry has given warmth to the couple yet retained the coolness of the evening city. Take note of the way the bride is positioned and how she holds the groom's hands. ▼

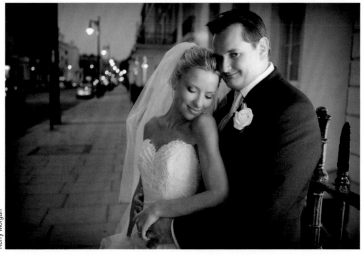

Kerry Morgan

Jose Del Valle

This shot breaks the rules a little by having the bride slumped in the chair and not sitting forward. This is intentional to create the look of this shot, with the groom in a posed yet relaxed position. The vignette and processing lend an "old time" feel to the image.

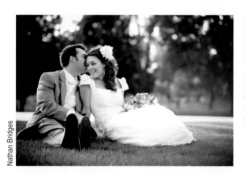

Nathan Bridges

Recognising back lighting and using it can transform your images. Photography is about light and how we use it. This was taken in late afternoon so the sun was low in the sky and not too strong. Nathan asked the bride to kick her legs back which naturally moved her body towards the groom.

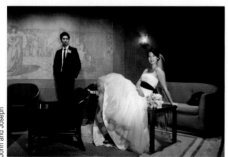

John and Joseph

Use hotel lobbies and lounges as well as the grounds. As demonstrated here, you do not need to be restricted to chairs - enabling you to create less obvious shots. Try something different, though always ask permission from the staff first. This image allows us to see the bride's shoes which are usually hidden for most of the day.

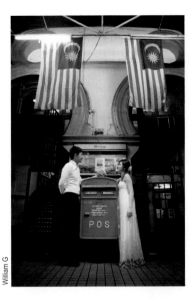

William G

Using everyday objects that are instantly recognisable as a part of a county's make up is a nice idea. There is a lovely symmetry within this image which is broken by the left hand gate being open. This makes the shot more visually interesting to me. Take note how the symmetry is also broken by the groom's arms being folded behind his back and the bride's simply hanging down.

Posing does not have to be complicated. By using objects within parks and grounds of venues, you can frame your subject and create simple yet highly effective images to complement more dramatic ones. Having taken a shot like this you might bring the bride forward and shoot wide open with a zoom lens, to retain her clearly but throw the groom out of focus in the background.

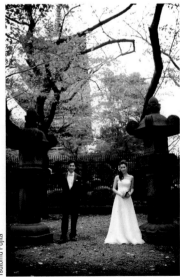

Tsutomu Fujita

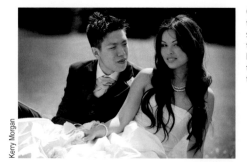

Kerry Morgan

On dry days it is quite acceptable to ask the bride and groom to sit on the grass, without fear of the dress getting dirty. Kerry has placed the couple carefully to avoid dappled light falling on their faces.

You will often find doorways like this if you look around your environment when shooting city weddings. The key lies in not making it look cheesy, which is accomplished by developing good expressions and poses. This is a fine line so be careful and pay attention to all the elements in the shot.

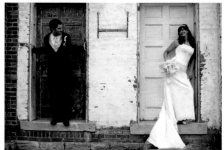

Chuck Arlund

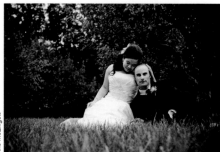

Kris McElligott

When shooting couples on the grass try to vary the shots you take. Perhaps start shooting standing up and then lie on the floor as Kris has here. Use a shallow depth of field to blur the foreground grass and if shooting wide have the couple off-centre. I love the way the bride is holding the groom by his head and bringing him towards her. The tree branch frames them nicely.

This is a perfect example of the type of image you can create if you ask one of the couple's friends to stand to the side of you and make the bride and groom laugh. This image really benefits from the flowers in the foreground adding colour and framing the couple.

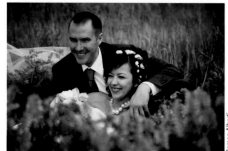

Romeo Alberti

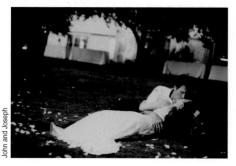

John and Joseph

This is a reflective shot – as if the bride and groom wished to escape from the wedding for a few moments alone together. As always, take note of the hand positions and how gentle they are. Note how confetti has been arranged around the couple and what it does for the image.

We probably photograph the bride and groom from the front or side 99.5% of the time, so why not try to take a selection of shots from behind at each wedding? It will enhance your coverage, add diversity and visual intrigue to the album, and evoke memories as your mind works to visualise the couple's expressions.

Charlotte Geary

DQ Studios

Again D&Q demonstrate why you do not need to see someone's whole face. The shot is about the groom, but look at the bride's elegant pose and the way she holds her hand up to her neck. It was a masterstroke asking the groom to adjust his bow tie.

Mario Sales

This was taken in the late afternoon and incorporates intentional flare from the sun. I love the way the bride is posed and we have separation from the groom, who is rendered out of focus due to the shallow depth of field.

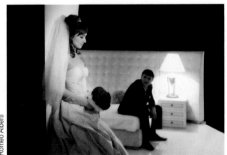

Romeo Alberti

Video light has been used effectively to bring attention to the bride, who has been asked to look at her flowers. The groom is purposely unlit but looking towards the bride. Warmth has been continued in the room by having the table lamp switched on with the seam of the shade at the back.

What does this image and pose tell you about the bride? She is beautiful, elegant and refined. Her dress is gorgeous and her husband looks on lovingly as she is photographed in a fashion style. Her body is angled away, giving a natural separation between her waist and arm. By shooting from a low angle you can add height to the subject. Look at the groom: can you see that Chuck has placed him so the sun falls on the furthest side of his face?

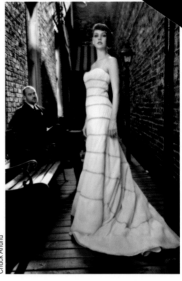

Chuck Arlund

Jose Del Valle

Another doorway shot. Here José has asked the groom to place his feet away from the door frame so he can lean against it at an angle. His look has been finished by having him cross his legs and tilt his head. You need to be careful when doing this with men and ensure it tilts to their lower shoulder. The bride is almost in profile but her head is turned slightly. Remember to shoot wide to incorporate architecture in your work.

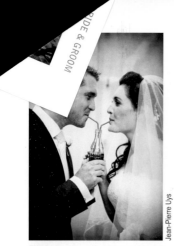

Jean-Pierre Uys

This is just a really nice and playful fun pose.

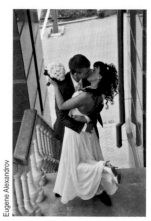

Eugene Alexandrov

The railing takes you towards the couple. They have been asked to kiss while the bride is lifted and kicks both legs out.

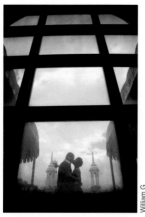

William G

Shooting from inside, William has captured the couple outside and framed them within the window and between the two structures in the background.

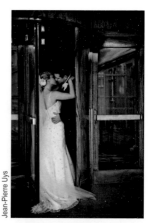

Jean-Pierre Uys

It is a lovely idea to use the revolving doors to pose the couple within, but be careful no-one comes through as you are shooting. We can see the back of the dress and the bride's arm and wrist are bent.

Once you have your safe shots taken then have a play and be artistic. I love the way the couple are looking in different directions and how Chenin has asked the bride to softly touch the groom's leg. As we saw previously, by including little elements like showing the bride's shoes you really elevate the quality of your work. This angle also allows us to see all the layers of the dress, giving it body.

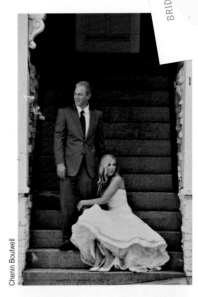

Chenin Boutwell

If your couple have a church ceremony then it is a perfect place to take them back into for formal images. There are so many opportunities presented to you that it can be hard to choose where to shoot. As well as straight on to the altar you can try shooting across the church; isolating details; from the balcony if there is one; or use the pews to lead you to the couple. If it is very sunny, causing unflattering light, then why not take the family back inside for the group shots?

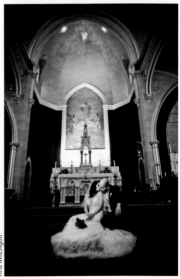

Kris McElligott

163

You can see how soft this image is with its beautiful backlighting. The bride and groom hold hands by their fingertips and the bouquet adds a little colour into the image.

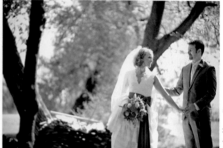

Tasha Herrgott

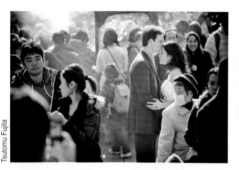

Tsutomu Fujita

This is a lovely style to use in a busy city or even with guests. Ask the bride and groom to embrace in your selected pose and then take your shot whilst everyone else is moving and doing their own thing around them. There is a sense of solemnity surrounding this. You can also select a slow shutter speed to blur the passer-by.

The backlight shines through the grasses, giving them a beautiful illuminated effect. The light is also very soft, adding romance and beauty to the image. The groom is no doubt speaking to the bride causing a natural smile. Again a shallow depth of field was used.

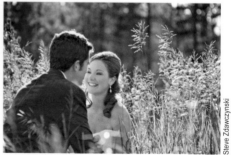

Steve Zdawczynski

What beautiful light! Pay particular attention to the way Chenin has directed the couple almost to touch heads but not quite. By doing this (or asking them to slightly touch each other) you create a far greater sense of romance and elegance. It is this type of shot that elevates your work.

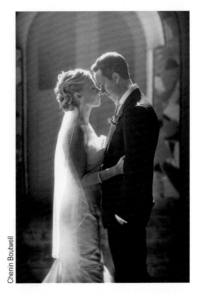

Chenin Boutwell

A great use of backlighting here, and of the bike. Notice how the bride holds the groom's hand very delicately. It is as though the bride was waiting for the groom, he arrived, leant in and kissed her. You will often find props, so if the opportunity arises try to use them.

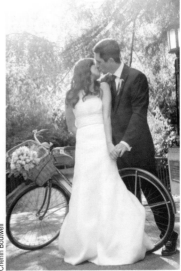

Chenin Boutwell

You can see that this shot was backlit so Romeo has used a reflector to bounce light back into the brides face. If you do not work with an assistant then it is perfectly acceptable to ask a member of the wedding party or enthusiastic photographer to do this for you. The bouquet has been placed using the rule of thirds.

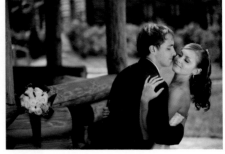

Romeo Alberti

You can see that this shot was backlit, so Romeo has used a reflector to bounce light back into the bride's face. If you do not work with an assistant then it is perfectly acceptable to ask a member of the wedding party or an enthusiastic photographer to do this for you. The bouquet has been placed using the rule of thirds.

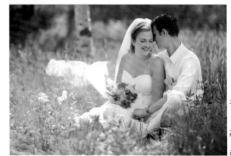

Steve Zdawczynski

A piece of confetti or a flower petal can make an interesting prop. Olga has asked the groom to blow a kiss to the bride whilst he is holding the petal in his fingertips. But you have to be careful not to make this a cheesy shot. This is achieved by the backlighting and the bride looking down.

Andriyash Olga

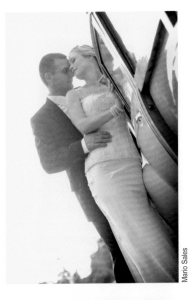

Mario Sales

This is a really interesting composition using the old car as a prop. The bride is leaning against the car with her hips whilst her knees are bent and her left leg slightly bent. Her hands are lightly clasped together and almost out of view. She turns towards the groom, who holds her from behind by the hip. Her head is tilted and he dips his head down onto her temple.

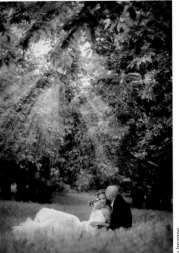

Unique Images

Mark asked the couple to sit in the middle of this row of trees that were in blossom. He got low and shot wide to incorporate the overhanging branches with the red flowers. The groom had picked one earlier and can be seen here kissing his bride whilst giving her the flower. She is positioned horizontal to the camera whilst his body goes away from it, making a T shape.

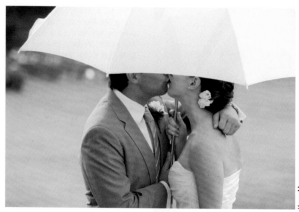

Kerry Morgan

Take an umbrella to use as a prop as it can be a useful tool and has many purposes. If it is a hot sunny day you can use it to block the sun or diffuse light. Kerry has taken a lovely shot here, with both the bride and groom holding the umbrella. By choosing to shoot from a higher perspective than the couple, she could effectively not include the upper part of their faces, lending an air of privacy.

Leslie Gilbert

In this example Leslie has cleverly used the umbrella to create a silhouette of the bride and groom. You can create this anywhere by using an off-camera flash with the head zoomed and directed towards the couple's faces.

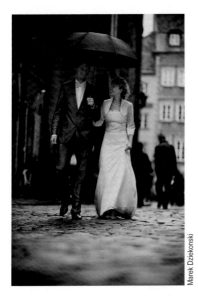

I love this shot of the couple walking down the street. Marek has got down to ground level and waited for the couple to be in a position where they are framed within the dark building. Shallow depth of field highlights the couple and his timing is perfect in terms of the expressions and the groom's foot being mid-step and elevated.

Marek Dziekonski

This style of image is timeless. It could have been taken in any city and at any time. It is only by having the heightened observational skills that allow you to find and visualise this style of image that you will able to take it. Thought has gone into every detail, including the reflection on the pavement which combines with the use of an umbrella.

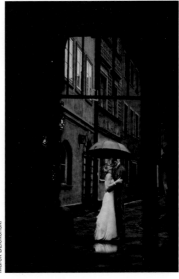

Marek Dziekonski

William G

If you are lucky enough to shoot beach weddings then survey the local surroundings for small piers that you can pose the couple on. A couple of flowers add a little colour to the image.

Emma Hughes

By shooting from a low angle Emma has managed to include a lot of the sky, which is in contrast to the green of the grass. Generally you need to shoot with the sun behind you to capture a blue sky. Instead of a static shot, drama and movement have been added by asking the couple to run.

Andrey Demotchenko

Andrey likes combinations of warm colours and geometrical lines. In this picture the lines direct the viewer straight to the newlyweds. Andrey asked the bride to lift her dress with her hand (so her leg was visible to the knee), and the groom was asked to hold the bride's waist and to pull her strongly to himself.

If a wedding is in Bordeaux, where wine is part of the culture, you have to incorporate it into your work. Kevin wanted to imply that the couple were lost within one of the vineyards. The tractor paths add visually to this image.

Kevin Tran

I wanted to use the low hedge and overhanging tree to frame the bride and groom, whilst showing the spectacular venue that they chose for their wedding (Eastwell Manor in Kent, England). The shot is about the venue as much as the couple, which is important for the album.

David Pearce

Kris McElligott

Panoramic images work very well but don't overdo them. A few within an album is perfect and makes them stand out. The couple are seated to the right to allow negative space. On this occasion the bride has adopted the main position with her head above the groom's.

Kudegraphy

This is a really interesting angle to shoot from and highly effective. Taken from a first floor window and shooting down, the newlyweds have been positioned so as not to look awkward, by having them slightly offset. They are cheek to cheek but separated, which enhances the image.

John and Joseph

A great image that shows the train and extent of the dress from above. Look at the way the bride's head is angled and how she carefully places her hands on his shoulders. The expression is wonderful.

Romeo Alberti

This started as a natural moment which Romeo captured well. Often though, we can see lovely moments but are not in the right position to capture them. It is okay to ask the couple to recreate what they were doing, for you to photograph. This will result in staged yet natural images.

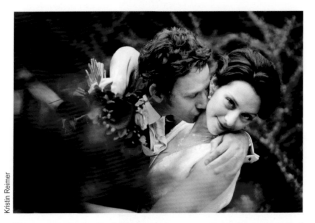

Kristin Reimer

The groom is dipping the bride here but you can only see the upper half of their bodies. I particularly like the way the groom is holding her and then kissing her neck.

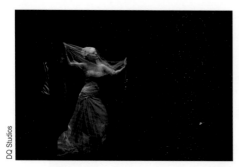

DQ Studios

I am a big fan of low key images like this. As the light is coming from the side it highlights the details on the bride's dress. She has her arms extended to show the veil and is looking up which is accentuating her neck. You can just make out the groom standing at the bride's side.

Jean-Pierre Uys

It really pays to use a variety of lenses when shooting, to give different perspectives. Here Jean-Pierre wanted to show the beauty of the landscape where the wedding venue was located. He has asked the groom to hold the back of the dress as they walk.

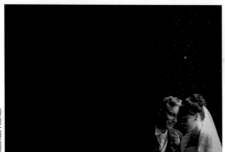

Matthias Richter

Look for locations that allow you to place the bride and groom in the bottom corner of an image. Here the background has been totally eliminated so all attention is diverted to the couple.

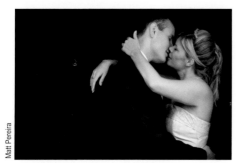

Matt Pereira

This is a beautifully executed image of the bride and groom kissing. Their lips are almost touching but not quite, her right hand falls naturally behind the groom's shoulder, and she gently holds his neck.

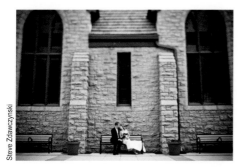

Steve Zdawczynski

Steve has used a tilt shift lens to take this image, which serves to almost straighten the verticals and add blur to the edges. The couple have been positioned in the centre of the image but at the bottom, with the long vertical window seemingly pointing towards them.

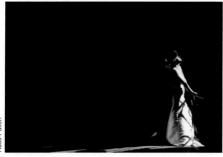

Russ Pullen

An example of finding and using a pocket of light found late in the day when the sun is low in the sky. The is holding the bride at her hips as not to surround her. Her head is tilted backwards allowing him to kiss her just below the ear.

175

Here the bride has lifted her right leg to give shape. By having her hold the dress up by the loop and hold her husband's hand, Eugene has brought them together. The deep depth of field allows the city to be seen in the background.

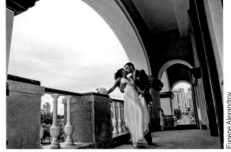

Eugene Alexandrov

The bride and groom do not have to be prominent within the frame. Sometimes just a glimpse is just as effective and can tell more of a story.

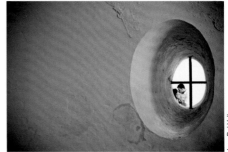

Jose Del Valle

This shot works on many levels. The railing leads down to the bride and groom who are contained within the arch of the building behind them. The bride has been positioned on a higher step than the groom, reversing the more common positioning of the groom being higher. This has allowed her to kiss the groom's forehead.

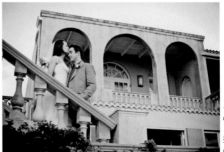

Du Wayne Denton

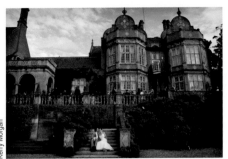

Kerry Morgan

Grand buildings deserve grand images and this example by Kerry could easily grace the front cover of the wedding album. It is a portrait of the wedding venue with the bride and groom, who are complemented by their guests in the background.

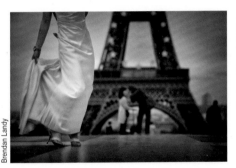

Brendan Landy

Brendan's intention was to create a portrait of the bride's dress and shoes whilst including out of focus the iconic backdrop of the Eiffel Tower. He chose to keep the couple in the background in the shot as they were having their own romantic moment and it brought the image together.

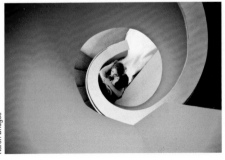

Karen Bridges

The architecture leads you to the newlyweds. Karen took special care to have the bride look slightly upwards whilst the groom kissed her. This was to ensure her face would not be obscured by the extreme upward angle.

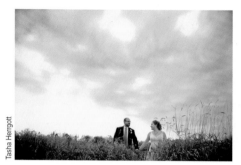

Tasha Herrgott

Tasha had asked the bride and groom to walk hand-in-hand towards her behind this hedge, and to look at one another. The sky was dramatic which is necessary if you are going to include a lot within your composition.

This is an even more dramatic sky with the horizon running through the middle of the image. Marija wanted a fun shot so asked the bride to climb onto the groom's back.

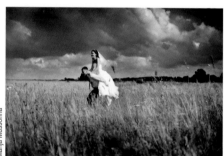

Marija Mussorina

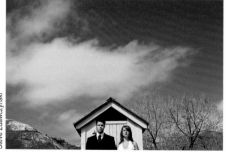

Steve Zdawczynski

Steve intentionally centred the couple in front of the hut, breaking the rule of thirds and making the image a little edgier. Tension has been created by doing this and the composition provides an alternative to the overdone "American Gothic" style photo.

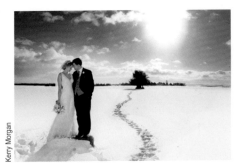

Kerry Morgan

This is a very carefully planned shot by Kerry. Knowing that there would be snow the couple brought wellies with them so as not to ruin their shoes. Kerry asked them to walk across the fresh snow following her footsteps, and then proceeded to take this lovely image. If you pre-plan shots you would like to take and explain them to the bride and groom, you will often find they are very receptive to them.

If a bride has a long veil then make the most of it, as Marija has. Using motion works exceptionally well, and you can ask the groom to interact with the bride behind the veil. Ask the bride to use her hands to show the size of the veil.

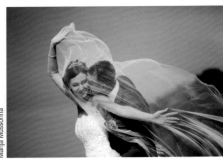

Marija Mussorina

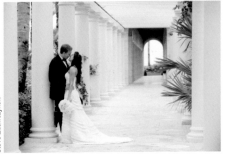

Steve Zdawczynski

This is a fairly standard shot to use when you have repetitive columns, as it shows the architectural elements very well. Have the bride or groom lean up against the column and enjoy a light cuddle or embrace. Make them laugh, and zoom in for a closer shot to give variety.

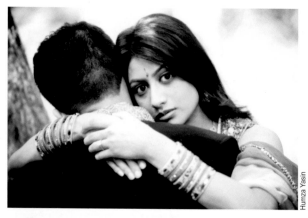

Humza Yasin

A good example of this shot, with the bride placing both arms around the groom. Notice how the arm most in view is on top of the arm that is less in view.

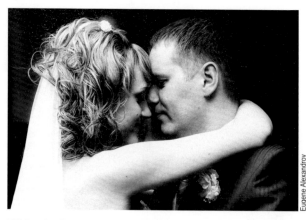

Eugene Alexandrov

This is a shot that can be taken almost anywhere. Use a shallow depth of field, ask the bride to hold the groom around the neck and to bring her forehead onto the bridge of his nose.

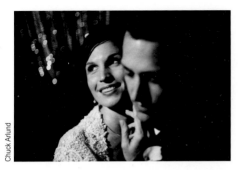

Chuck Arlund

A fantastic image. The bride is lit from the side and Chuck has asked her to turn into it whilst smiling and stroking her grooms face with the back of her hand. The groom has been left out of focus, looking down and only lit partially.

Leslie has very successfully incorporated many elements into this shot. She has created intrigue by cropping beneath the eyes, having the bride's nose closest to the camera, and the lady's hand placed very softly on top of the groom's. Her left hand is only touching the piano with its fingertips and we have a reflection in the piano to finish the composition.

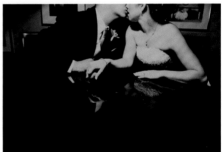

Leslie Gilbert

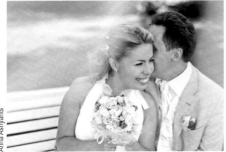

Anna Asriyants

This is a perfect example of the reaction generated by asking the groom to whisper something romantic or funny into the bride's ear. The bride's expression is priceless. It has been shot wide open through foliage, creating this beautiful natural and soft vignette.

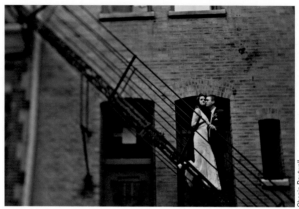

Chenin Boutwell

I love the way that Chenin has placed the bride and groom on the steps and within the frame of the door. The railing leads you into the image and cuts across the rectangles. Look at the directions Chenin has asked the couple to look in. The low angle really lends itself to this image.

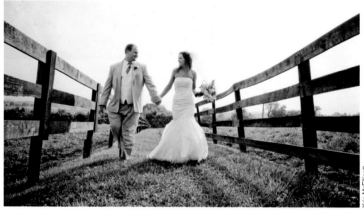

Kris McElligott

The fence acts as a natural frame and leading lines into the bride and groom. Shots of the newlyweds walking are always popular, so look for locations that lend themselves to it. Have them hold hands and look at one another to show the connection between them.

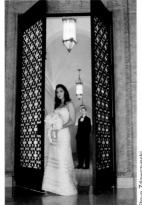

Steve Zdawczynski

Steve placed a strobe in the hallway to light the groom whilst the bride is lit with on-camera bounced flash. By learning these techniques new opportunities for shots open up to you.

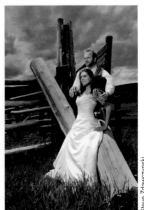

Steve Zdawczynski

To make the sky dramatic Steve has used off-camera flash. He always looks for structures he can utilise for posing and to add to the composition of an image.

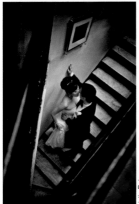

Kristin Reimer

The triangle formed by the staircase and banister is perfect for framing the couple. Always look for shapes that you can use like this.

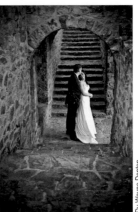

Du Wayne Denton

Du Wayne has asked the bride to lean back onto the groom and turn her head to face him. The groom has then kissed her on the forehead.

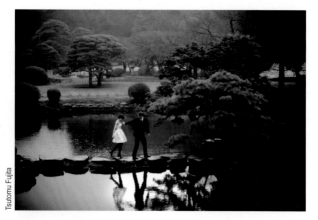

Tsutomu Fujita

Gardens and lakes are often a feature of popular wedding venues and the couple anticipate having beautiful images depicting them. As well as getting in close, take time to stand back and show the surrounding landscape. It may mean that you have to scout for a less obvious location but it is worth the effort. If you can include a reflection then your image will be enhanced.

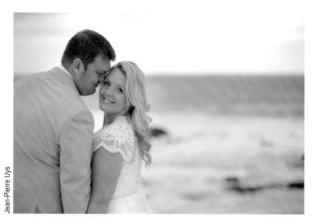

Jean-Pierre Uys

Take note of how the couple have crossed arms to hold hands, for a different look. The key with an image like this is not to have the groom apply any pressure with his nose on the bride's face. If he does so it can distort its shape.

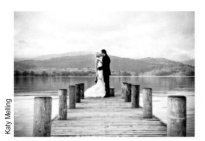

Katy Melling

This is another perfect example of adopting a lower position and using features as leading lines. In shots like this placing the couple in the "bulls eye" position works as it completes the symmetry. A very elegant image.

Standing a distance away Steve used off-camera flash to capture this image of the bride and groom dancing. He wanted to add drama in the sky but also to really bring out the colour of the grass. A lot of negative space was chosen to provide post-production cropping opportunities.

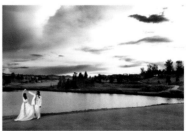

Steve Zdawczynski

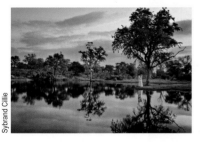

Sybrand Cillie

The colours in this image are beautiful, as is the reflection. Sometimes you really have to make an effort to see images like this. It is always a good idea to look behind you to see that viewpoint, and to think like a landscape photographer and wander off the path to find better shooting locations.

Brides and grooms love the dipping shot. If you can find a little less ordinary location to shoot it in then do so. The groom has adopted a strong stance to ensure he is well-balanced and is to the side of his bride. He is able to support himself whilst holding her up during the dip. She has her hand placed near his bicep to indicate his strength.

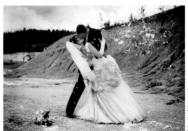

Marija Mussorina

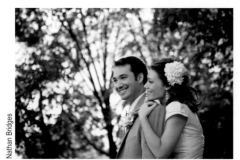

Nathan Bridges

If you find yourself with lots of background distractions, like Nathan did here, then look up. You may find that shooting from a lower angle and using trees provides an ideal solution. The bride was asked to wrap her arm around the groom's shoulder and pull him towards her.

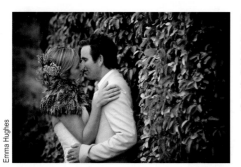

Emma Hughes

A classic example of how to make a fantastic image with a very simple background. The hedge draws your eye towards the couple who are placed off-centre. The bride's nose is on the camera side, as generally female noses are more pleasing to the eye than male.

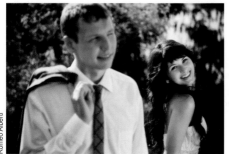

Romeo Alberti

You do not have to focus on the person in the foreground of an image. Instead have the couple separated slightly and one standing a little behind. It is very important that the person in the foreground is not looking at the camera, as this does not work. You can take an image showing quiet reflection or happy and smiling pictures.

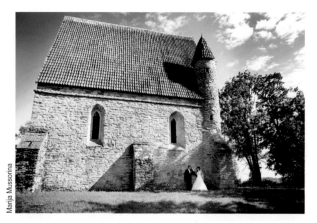

Marija Mussorina

This is a simple image that works well due to the blue sky and green grass. The shot is about the church, and the placement of the bride and groom puts the church's size in perspective.

DQ Studios

Another example of moving away from traditional locations that may be used for wedding photography and searching out new ones. To me this image is about Nature. The couple are barefoot, apparently exploring, and have found this waterfall.

Romeo Alberti

This couple has been asked to stand in a location where they are reflected in the window and framed within one of its panes. It also shows that the couple are by water.

Jose Del Valle

José has placed the couple by the pillar and instructed them to look out into the landscape. The groom has his back to the pillar and the bride has her side towards him.

Alexey Antanenko

The groom is taller so has bent over and kissed his bride on her upper chest. Her body is positioned in a 'C' shape. Her outstretched leg lends elegance to the image.

Kudegraphy

This couple has been lit from above with a cone of light from an off-camera flash. They are both looking quite serious, and down towards the camera.

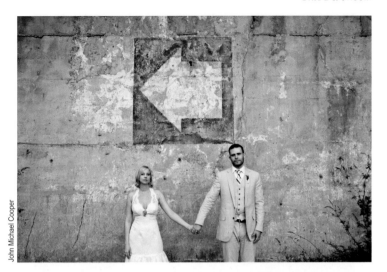

John Michael Cooper

This image taken by John Michael Cooper is elegantly sublime. Although it appears relatively easy to take it is far from it, due to the many components that make it work so well: the groom's suit blending well with the background, the mirror image they have adopted, the expressions, and of course the arrow pointing away.

This is one example of when tilting an image works. By doing so Kevin has been able to include the fabulous door and roof along with the couple. They have stood in a position that emulates a dance. It is always a good idea to look up to find interesting architecture or painted ceilings. By shooting at different angles and heights you break the monotony of eye-level images.

Kevin Tran

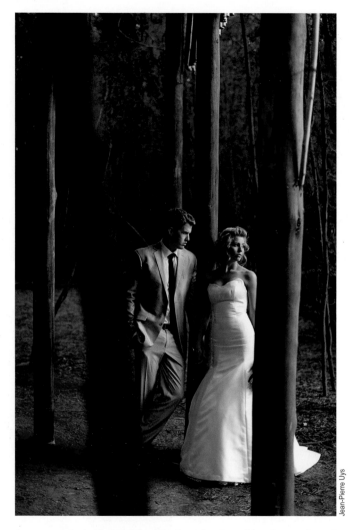

Jean-Pierre Uys

A very magazine-inspired pose framed between two trees. I love the casualness of the groom with his hand in a pocket and legs crossed. He is connected to the bride by holding hands and the shot is lit from an off-camera flash from the right. You can tell this from looking at the shadows.

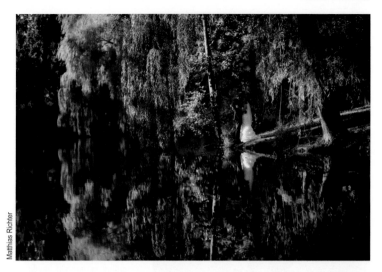

Matthias Richter

By placing the bride and groom under the canopy the bright sun has only caught the bottom of the bride's dress. This image could almost be an oil painting, with the overhanging trees and reflections. This style of image tells us a lot about the romance of the day.

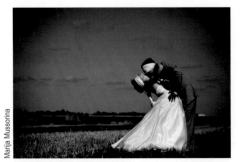

Marija Mussorina

Marija has taken blindfolds in her bag to use as props in this dipping shot.

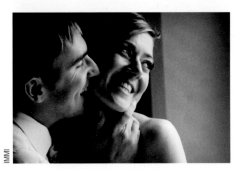

IMMI

Shot with available window light, this couple were very playful. Asking the groom to hold the lady gently by her neck and whisper something in her ear produced this lovely result.

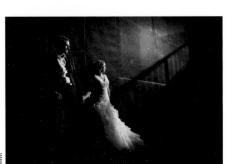

IMMI

This is a really interesting composition with both the bride and groom having their back to the wall. Off-camera flash has caused the shadow of the staircase. I love the way the bride is looking away and along the wall.

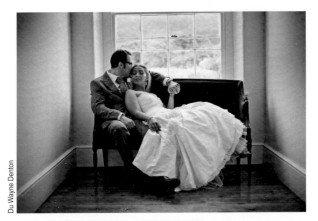

Du Wayne Denton

This shot shows a moment of quiet reflection by the bride and groom. It works well as she is leaned back into the groom and has stretched her leg out. He carefully kisses her softly whilst holding her hand. If she had turned around to look at him it would have caused unsightly lines in her neck. The bride's face is also angled slightly up to create a perfect chin.

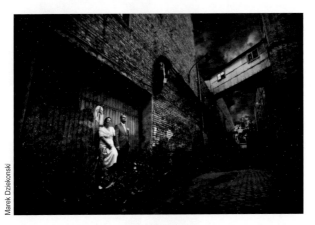

Marek Dziekonski

The unconventional location played a large part in this image, which is very dramatic. It is another example of having both the bride and groom stand with their back to the wall. The bride is holding her dress up a little and bringing it around her body. The couple have been made brighter in post-production to help them stand out within the frame.

In this image I got low down to the top of the iron railing to lead the viewer into the couple. This was a last-minute shot - the bride and groom were ready to rejoin their guests but I managed to talk them into one final image which turned out to be one of my favourites.

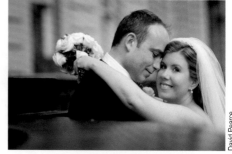

David Pearce

When Andrey discussed places for shooting, the newlyweds suggested driving to the woods to a place where the groom had made his proposal to the bride. On the way back to the car, Andrey noticed part of the groom's coat was covered in snow and had the inspired idea to draw a heart there.

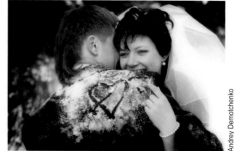

Andrey Demotchenko

Great light and timing, with the wind catching the bride's veil.

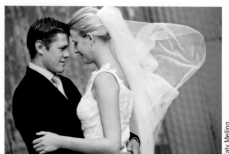

Katy Melling

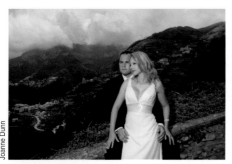

Joanne has captured the stunning Italian hillsides perfectly here, using off-camera flash to really bring out the couple from the background. If you find a high enough wall then you can sit the groom on it and ask the bride to stand between his legs. He is gently holding her at thigh level whilst she has her hands delicately placed on his knees.

Joanne Dunn

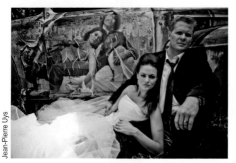

When you work with naturally cool people you can really emphasise this fact. Here Jean-Pierre has noticed the painting on the car door and asked the couple to emulate it but with a twist. He wanted the couple to look more confident and assertive, for a fashion-style look.

Jean-Pierre Uys

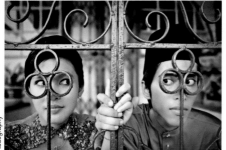

A fantastic shot. I love the way that the couple are both looking through the detail in the gates and at one another. The joining of the hands finishes the image.

Kudegraphy

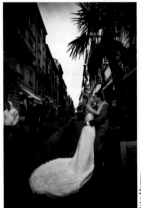

Jake Morrow

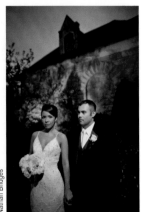

Nathan Bridges

I love the way Jake has taken this couple onto the street to photograph with everyone walking by. It looks good to have the bride's arms around the groom's neck.

Nathan spotted this orange backlight and used an off-camera flash to light the couple. The groom was not feeling it, so was asked to look off to one side.

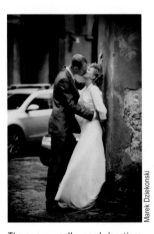

Marek Dziekonski

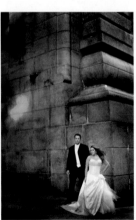

Kristin Reimer

There are really good locations everywhere you look in cities. A simple corner can prove very effective.

Here is another example. Kristen has asked the couple to stand in a very dramatic position and lit them with a flash.

Having the bride's arm hanging straight is not normally something I would recommend but it really works here. It looks like a natural movement due to her cute expression. I love the way the groom is only holding her hands with his fingertips and lightly presses his face against hers.

Jean-Pierre Uys

Steve Zdawczynski

Sometimes the couple have image requests, and in this instance wanted an American Gothic style look. The yellow background was very appealing but the light was not the best. Steve used flash to direct some light onto the couple and lift their eyes and the background.

Nathan Bridges

The composition in this image is superb. Nathan has included the whole of the entrance way leading to the door the bride is standing in. Her leg is pointing towards the camera, giving shape which is further enhanced by her hips facing the same way. The groom sits in a casual way but with a more serious pose.

Nathan Bridges

Walking through an old mountain town Nathan noticed this old door front. He used off-camera flash to light the couple and create the shadow falling behind the bride. The pose is playful and a little quirky, which is balanced by the seriousness of the groom's expression

This was actually taken on a relatively still day but I wanted to capture the bride's veil flowing behind her as it was so nice. To do this I asked someone to hold the veil fully extended and then throw it up into the air. They then retreated out of shot leaving the veil in this beautiful position.

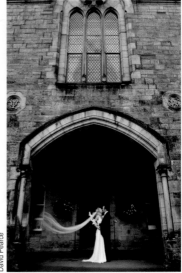

David Pearce

A simple shot that has been transformed by having the bride lift her dress to show her shoes. She has her left leg forward, adding body to the dress and elegance to the pose. There is also a strong imaginary diagonal line between their eyes which is compositionally strong.

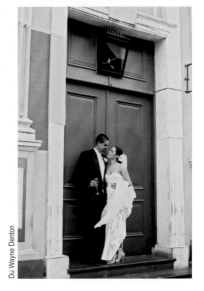

Du Wayne Denton

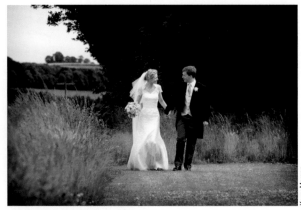

Kerry Morgan

Kerry has crouched down a little to take this shot. Framed slightly off-centre the couple walk towards the camera hand-in-hand. The grasses in the foreground add depth to the image. Very Romantic.

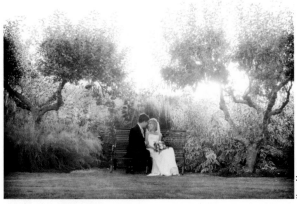

Kerry Morgan

This has lovely backlighting and is very soft. Placing the couple centrally has worked as they are framed by the trees, whose branches come down almost to point towards the couple. The bride has her legs crossed and the groom has his elegantly angled.

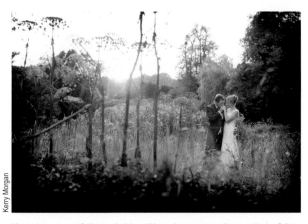

Kerry Morgan

Kerry has successfully used this wild garden to pose the couple in. I love the way in which the groom is holding his bride's hand to kiss it. It may be hard to see but they are both looking at one another. Flare has intentionally been included.

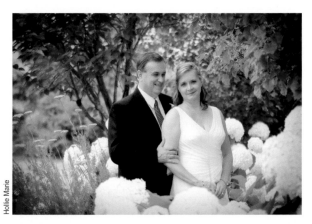

Hollie Marie

I love the way the groom here is looking lovingly at the bride. She has her hands positioned softly and away from her waist. The shot demonstrates the benefits in looking for locations that you may not always think of yet are all around us in season.

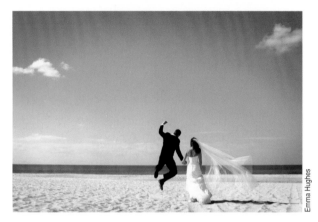

Emma Hughes

The groom here has been asked by Emma not only to jump but also to throw up his arms. Emma has instructed the couple to wait until a gust of wind blows along the beach to catch the veil, adding an extra dimension.

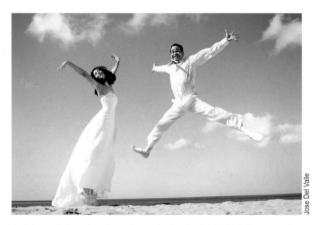

Jose Del Valle

José has got down low to really emphasise the height that the groom has jumped into the air. The couple have been asked to really exaggerate their jumps and José has included part of the beach as an indication of the location.

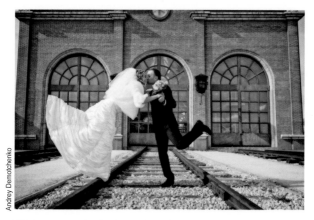

Andrey Demotchenko

This image was taken by chance during the posed session. Andrey had asked Olga and Dima to pass on the tracks like a tightrope walker balances at height. Dima slipped off and stood on the ground so Olga started to sway in an attempt to hold him. Dima tried to support Olga instead, resulting in this wonderful image. The lesson here is to be observant and ready at all times to capture moments like these.

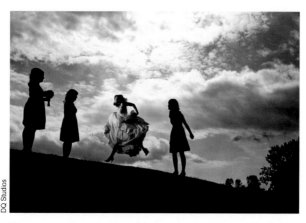

DQ Studios

This is a very clever and well thought-out shot. It is a silhouette but with the bride lit by an off-camera flash. The genius lies in asking the bride to jump into the air but also as if it is an exaggerated run. The bridesmaid on the left is also leaning forward with her arms back.

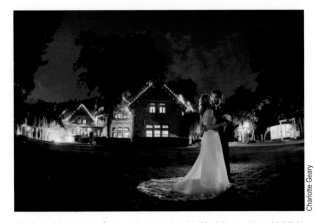

Charlotte Geary

Charlotte has placed a flash on the ground and behind the couple to highlight the dress and provide beautiful rim lighting around their faces. This shot is about the groom (as we can see his face) but also detailing the bride's dress. Notice how he is holding her and that they are hip to hip.

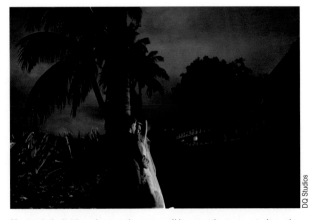

DQ Studios

If you ask the bride and groom they may well be receptive to a portrait session during the evening when the sky is a beautiful deep blue. By using a video light you add warmth. The bride is leant back against the tree with her hand extended back over her head.

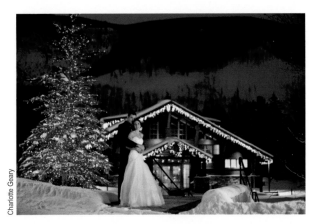

Charlotte Geary

Charlotte has really captured the essence of a winter wedding. I am sure it was very cold but providing the bride and groom with coats which they remove just before the shot is taken can alleviate any concerns. As you can see the effort is well worth it.

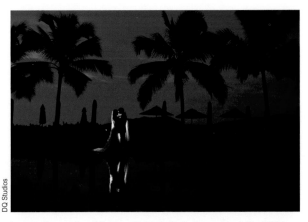

DQ Studios

Learn to be creative with your off-camera flash. Can you use it like D&Q have here, behind the bride and groom, to create such beautiful images? What is still a silhouette has been enhanced by the flash, allowing us to see the couple more clearly.

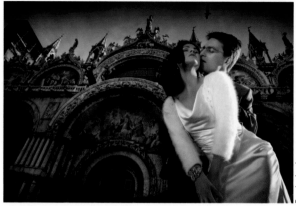

Brendan Landy

Brendan chose a low angle to avoid tourists being in the image. When shooting from this angle it is always wise to get your subjects to lean towards the camera and to try and maintain parallels with the camera to avoid distortion of the subject. The bride was able to lean a lot by positioning her hands on her knees, and also gave Brendan a lead-in line to their faces.

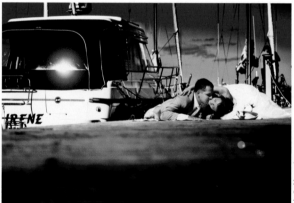

Marija Mussorina

Marija has lain on the ground to be at the same level as the bride and groom, so as not to show the sheet they are lying on. I love the way the bride is extending her head backwards, allowing the groom to kiss her neck. It is essential that the bride does not look towards the camera as this would cause wrinkles in her forehead.

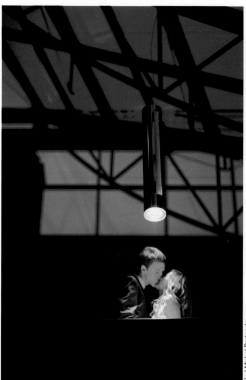

Ela I Michał Barłeczko

A young couple standing in the light of a lamp against the background of the blue sky at sunset. The couple loved to kiss so they were asked to stand under, but slightly behind, the light to illuminate them. Set your white balance to tungsten to really bring out the blue in the sky when using a video light or flash.

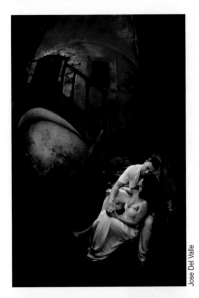

Jose Del Valle

This was taken in an historic fort with virtually no natural light. José placed a flash on a higher level and directed it down towards the couple. As this would have caused strong shadows he also used an on-camera flash to balance the light. The couple are almost intertwined here which I love. If you are shooting in an old stone building then why not experiment by using gels on your flash to add colour?

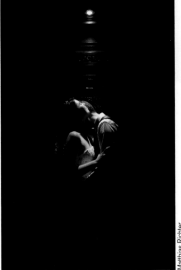

Matthias Richter

I have always really liked low-key images for the romance and intrigue they bring. You only need a minimal amount of light to take them and they look so different from more normal images. The bride has been asked to look up into the spotlight to light her face and shoulders. If the groom had his head tilted upwards as well it would lose the romance and look a little odd. Instead he has leaned forward and kissed her neck.

This was taken from a staircase looking down at the couple. The only lighting was from behind them, so José used a video light. Pay particular attention to the way the bride is standing. Look at the curves that have been created by pushing her hips out to the right and bringing her leg forward. She is holding the groom's hands and has her head tilted up.

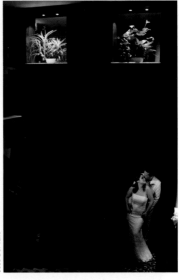

Jose Del Valle

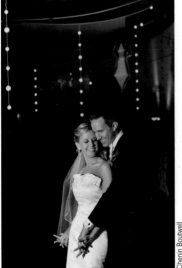

Chenin Boutwell

Notice the couple's expressions in this shot and the way they are naturally holding hands. The hanging lights lead you down to the couple. How you interact with the bride and groom has a great effect on the expressions the couple have. Interact with them and encourage the look you are aiming for. Try changing your tone of voice or speaking softly for romantic shots.

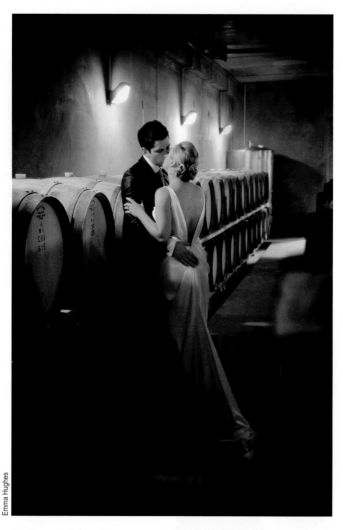

Emma Hughes

This image is all about the romance and the bride's dress. The beautiful design allows the bride's back to be seen. The bride will love this aspect so it is important to capture it. It is always worthwhile asking the bride what details or design elements she particularly loves so you can take images like this.

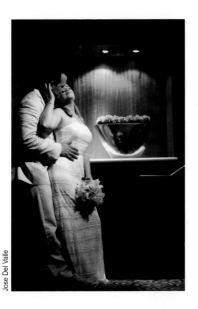

Jose Del Valle

The bride has her hips back and into the groom. She is standing tall with her chest filling the dress. Be careful when asking a bride to hold the groom's face when she is in front of him as it can look awkward.

I fully admit that I do not know how John Michael has taken this fantastic shot, as we cannot see the downlights creating the shapes. I have not asked, as I like to ponder over these things: it allows my mind to generate creative ideas which I can then try to use in my work.▼

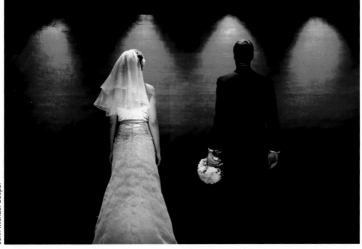

John Michael Cooper

211

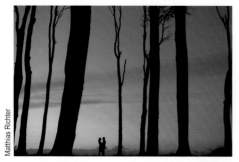

Matthias Richter

The three images on this page all incorporate silhouettes and strong vivid colour. Two have been taken outside, with perfect timing to really capture the tones in the sky. You have to be prepared for this as the sunset and twilight may only last a few minutes. If in a modern hotel then head to the bar to see if there are any strong colours for you to use as a background.

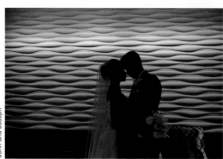

John and Joseph

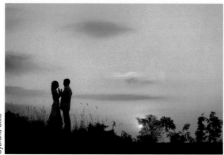

Sybrand Cillie

This shot works so well as the couple are not actually kissing – it is only their noses which are very slightly touching. Their bodies are separated in a flattering way as it gives space and shows the silhouette of both the bride and groom.

You can create images similar to this relatively easily with just a desk lamp. It appears that Matthias has placed the veil behind the couple and then had someone shine a light towards him whilst the couple just touch noses and foreheads. ▼

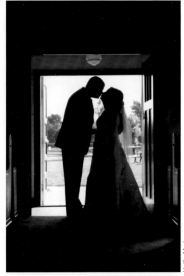

Hollie Marie

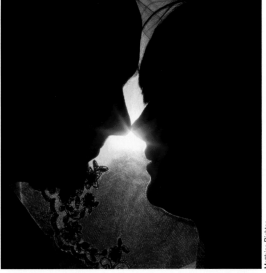

Matthias Richter

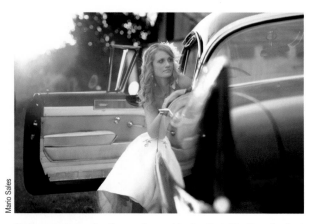

Mario Sales

Mario suggests opening the car door and having the bride sit on the front edge of the seat. This is very flattering and has been finessed by the bride's placement of her hands on the door frame. The backlighting is very important, giving the bride a hair light.

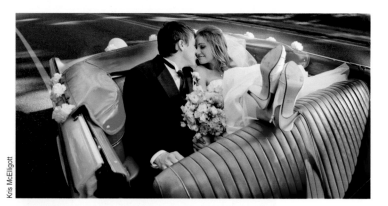

Kris McElligott

If you have an open-top car then why not try to get away from the standard shot and create something more fun and relaxed? It is usually the man who has his feet on the back of the seat so reversing this gives a modern feel to the image.

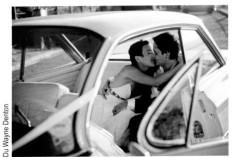

Du Wayne Denton

Once again this demonstrates how good photographers look for new angles on traditional images. Du Wayne has eliminated distractions by placing the couple in the car. The groom is sitting quite casually whilst the bride reaches over, holding him around the neck. The groom pulls the bride's leg towards him and they "almost" kiss.

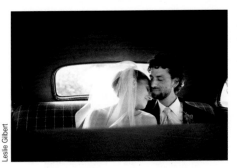

Leslie Gilbert

A lot of normal photographers climb into the front seat and take a shot of the couple and bouquet whilst looking at the camera. Set yourself apart and add class to your work by having the couple be romantic and interact.

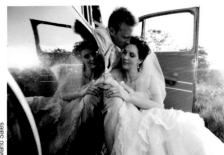

Mario Sales

Mario wanted a different car shot when he noticed the couple's reflection. He got close to accentuate it and had the bride sit on the ground and lean into the groom. This resulted in a composition that created a visually pleasing triangle with them and the reflection.

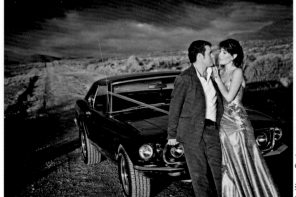

Du Wayne Denton

The groom leans casually on the car whilst the bride leans onto him. Take note of the left leg which has been crossed over her right, creating shape. Her hands and arms are placed over his shoulder giving a relaxed feel. The road and car go off at a diagonal.

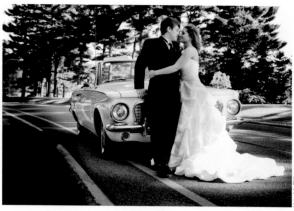

Kris McElligott

This is a similar shot to above but this time the bride's train has been included and she has wrapped her arm around the groom. The bouquet has been placed on the front wing of the car.

Russ Pullen

Russ had seen this sports car in London and the warm lights emanating from the basement restaurant. Standing on the opposite side of the road he asked the newlyweds to walk past with the bride in front, and for her to look back at him just as they passed the car.

Heather Zawalick

Heather has placed the couple in-between the wheel arch and windscreen, which acts as a natural space for them. The car appears diagonally and has been positioned here to take advantage of the tremendous light. Do not be afraid of asking the chauffeur to move the car into the position that is best for the photographs.

Joanne Dunn

If you can find a suitable corner for a relaxed group shot during the bridal preparations then make good use of it. Here the bridesmaids are all being themselves whilst the bride adopts a more posed position. You can really get the ladies on-side during the preparations - take shots like this and make them fun. Everyone will be more relaxed around you for the rest of the day.

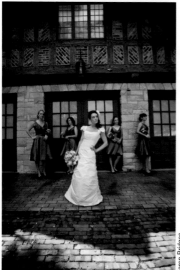

Karen Bridges

Group shots need not be boring and regimented, as you can see in the Group chapter and also on the following few pages. Try bringing the bride or groom out to the front and have them stand naturally or adopt a pose. If you look at this lovely example you will see the shadows from the building and also reflections of the sky in the top window.

Using a chair for group shots means you have a natural prop to build the group around. I like the way all the ladies' forearms are in similar positions apart from the flower girl. You can take this type of shot before the ceremony, which gives you peace of mind that you already have it.

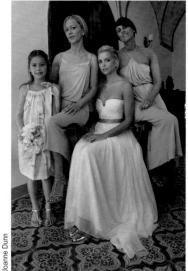

Joanne Dunn

To make group shots more interesting, try to incorporate anything that the party can sit on or lean against. This was taken in a simple pathway but has been broken up by the bridesmaid leaning against the wall.

Kristin Reimer

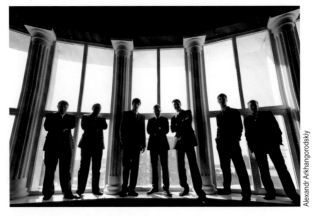

Alexandr Arkhangorodskiy

Alex has taken this from a low angle, giving drama to the shot. The men are all placed within the pillars and not in front of them. The pose has been broken up by having some place their hands in their pockets and others with arms folded.

Emma Hughes

By bringing the groom to the front of the image we immediately know his importance. The other reason that this image works so well is the way that the groomsmen are all looking in various directions. There really is no need for everyone to be facing the camera in shots like this.

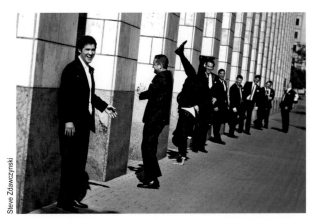

Steve Zdawczynski

Steve was trying to get everyone in focus with his tilt shift lens but was having trouble. He always has some banter going to stop them from getting bored and jokingly suggested someone doing a handstand. Sure enough one does and this causes the groom to laugh. Sometimes spontaneity works perfectly.

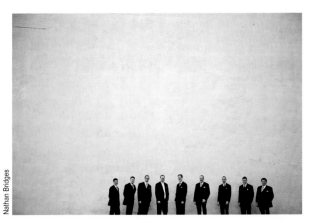

Nathan Bridges

Nathan spotted this wall and asked the men to stand in front of it. He initially shot it with a closer crop but was not really feeling it. It was not working for him. By stepping back and changing the crop he got it. Notice how the tallest man is in the middle with the shorter ones at the ends.

Scott Robert Lim

This is just a really good and fun group shot. If you have groomsmen who have the right personalities then just free flow and see what you can achieve. By letting your mind run free with the right group of people you will hopefully start to flow with creative ideas. If an idea is not working though, stop and move on to another, as time is precious.

Katy Melling

You can use the most unlikely locations to take shots of the groomsmen. It does not always work so well with ladies but the men lend themselves to it. Notice how effective this image is at showing the groomsmen, yet not one is looking at the camera.

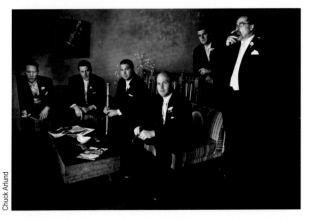

Chuck Arlund

Everyone has cigars but only the groom's father is smoking his. Is this a metaphor for something? It is very Soprano's to me and I love it. By shooting inside we can control the light and darken-off areas we may not wish to see. Look for hotel lobbies or lounges to take shots like this.

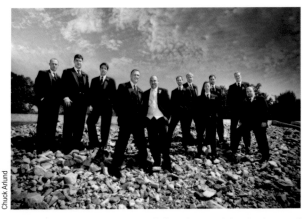

Chuck Arlund

Large groups can be hard to photograph. Here the natural slope has been used to position the men at different heights. The groom and best man have been brought forward to signify their importance.

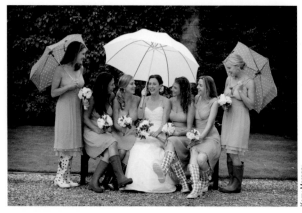

Kerry Morgan

I simply love the way Kerry has used the wellies and umbrellas here. Group shots can be fun and this certainly is! There is also attention to detail with two of the bridesmaids having their legs crossed, naturally drawing our attention to the bride.

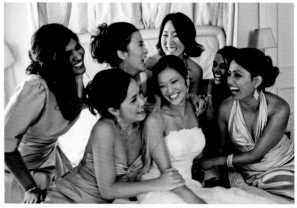

Scott Robert Lim

Scott has brought everyone together here and asked them to look at one another and laugh. Sometimes this can be hard so just start laughing yourself and eventually they will start to laugh at you. The ladies were positioned carefully before doing this.

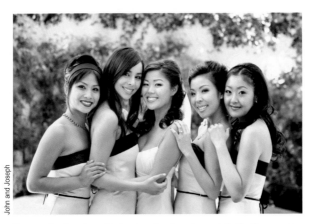

John and Joseph

Everyone has been brought close together here. I especially like the symmetry of the arms and how it connects everyone together, with the two ladies on either side having the same arm positions.

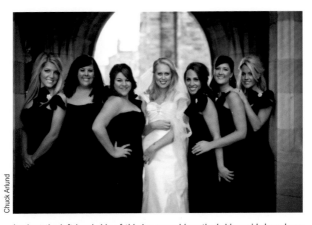

Chuck Arlund

Look at the left hand side of this image and how the bridesmaids have been positioned differently from the right. The ladies on the left are also connected with each other by the arms and hands.

Nathan Bridges

Nathan loved the geometry of the ramps and fencing in this skate park which was near where he was shooting. He asked the riders if they would perform jumps in the background and they gladly agreed. Nathan likes the groups to pose themselves initially before he makes any adjustments.

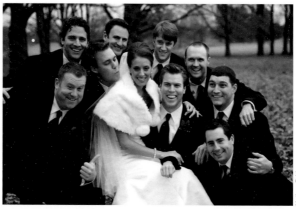

Nathan Bridges

Nathan says that this group had a lot of energy so he worked with it. He asked the groom to go down onto one knee and his bride to sit on it. He then instructed the rest of the men to rush in and get as close as possible. The laughs flowed and Nathan got many great shots.

Leslie Gilbert

As Leslie has done here, I often like to shoot the men from a lower angle to add impact. This is especially useful if you have distractions in the background. Leslie has asked all the men apart from the gentleman in the middle to look in different directions. This is a very effective technique.

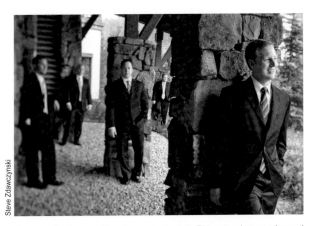

Steve Zdawczynski

Steve excels at compositional groomsmen shots. This was taken on a hot and sunny day so he searched for a shaded location. He used a tilt shift lens to draw a line of focus between the groom's face and the groomsmen. If he had used a standard lens wide open the groomsman at the very back would be so blurry you would not be able to see him.

Andrey Demotchenko

This photo was taken when everybody went to a veranda to get some rest. Somebody noticed the books and joked that it would be funny to make a picture with them. Andrey decided to use a method of identical objects in a shot, and asked everyone to hide their faces with those books. He wanted to show an interaction between people of the last century and of the present. The picture was taken using a flash which was directed towards the ceiling.

Emma Hughes

Be aware of the personalities of the bridal party. If they are fun, fit and playful then why not create a shot like this? If you do not ask then you will not get, so be inventive and see what you can achieve without being too outrageous. I love this shot as it says so much about the couple and their friends.

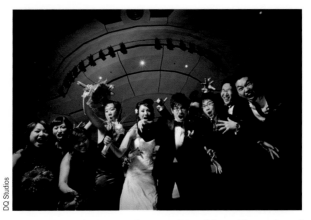

DQ Studios

Dave and Quin really bring out the personalities of the wedding parties and just seem to have so much fun being creative and pushing themselves to create great images.

DQ Studios

What a great idea to ask the wedding party to all get close and press against a window, pretending to be escaping, while you capture it from outside. Genius.

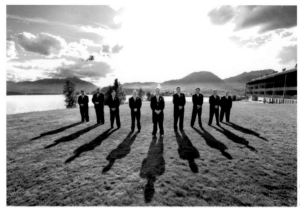

Steve Zdawczynski

This is a natural light shot that had blown-out skies and shadows on the faces. Steve achieved an HDR-look though through experimenting in Lightroom. He used the highlight recovery and fill tools with luminance sliders to bring back the sky. He doesn't usually go to so much trouble but sometimes it is good to explore software's capabilities, especially if you achieve results like this.

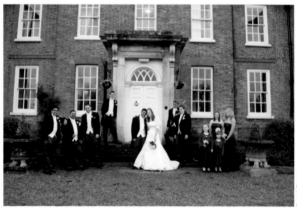

David Pearce

If shooting at a country house hotel then using the doorway and steps for groups always works well. I wanted to separate the party as there is no need for them to be in a straight line, military style. Try to make little groups within the larger group and have them adopt different poses.

Adrian Downing

Adrian has done something very similar to my image on the left hand page. Notice how the bridesmaids have their bouquets in their laps and not held up. This allows us to see the design and detail in their dresses.

Steve Zdawczynski

If you can use geometric patterns within your images it can add a new dimension. When doing something like this Steve reminds us to take a "safe" shot first and then have some fun. These shots do take a little time to organise but the results justify the extra effort.

Adrian Downing

Look at how everyone has been positioned within this shot. Almost everyone is different, making it visually very interesting. You want to look at everyone instead of seeing them as just one body of people. Break things up a little. Try some formally posed guests with more casually posed ones to create tension in the image.

Steve Zdawczynski

Again, get your safe shot and then have some fun. Here the groomsmen were not co-operating very well so Steve asked them all to turn and face the building in shame, leaving just the groom facing the camera. We need to train our brain to be creative, so when outside look at various buildings and visualise how you might pose a group there creatively

Audrey Amirhanian

Andrey has used the sun to create a shadow of the couple, whilst asking the groomsmen to cheer in the background. It is an inspired choice of wall due to the heart graffiti. If you try this then ensure the couple are positioned in such a way that you can see them both in the shadow.

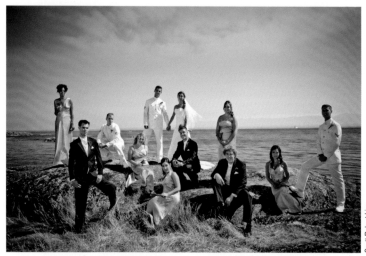

Scott Robert Lim

Do you have to have the bride and groom at the forefront of every frame? Scott clearly demonstrates here that you do not. He has asked the bridal party to use the rocks to either sit or stand on. Two of the men are crouched down, which offers something different from sitting. Try sometimes to have everyone in a different position to add to the image's visual appeal.

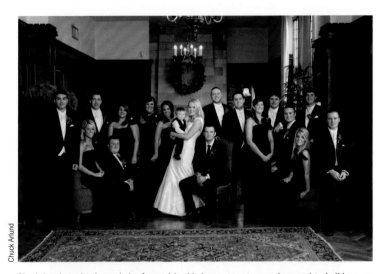

Chuck Arlund

Chuck has brought three chairs forward in this image to act as anchors and to build groups around. Notice how Chuck has directed people to sit on them. No-one is seated in what would be considered a conventional manner. Chuck has used the arms, had two people on one chair and ensured that those seated are forward in the seat and sitting tall.

Scott Robert Lim

Note how the groom is crouching down and the lady casually leans against him in a manner that is very cool and flattering to her. The groomsmen are angled in various directions and the gentleman on the right has been asked to fold his arms to break up the image.

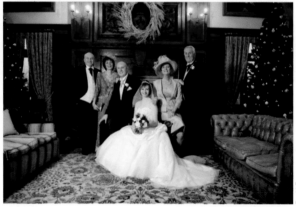

David Pearce

I love to take group shots inside where I can control the light. This was taken by bouncing an on-camera flash into a reflector behind me. I positioned the sofas to act as leading lines. I positioned a chair for the bride to sit in and built the groups around. As they got larger I used the sofa arms as well.

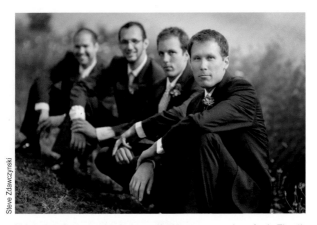

Steve Zdawczynski

This is a perfect example of when a tilted image can work perfectly. The tilt has been used to bring everyone into the frame.

Adrian Downing

When you have a church wedding head back inside to take family and group shots. It offers all sorts of possibilities for you, with the altar, pews and architecture. It will also allow you to escape inclement weather or harsh sunlight.

Occasionally we are only hired to stay until the speeches and therefore miss the first dance. The couple might still like a dancing image though, so we have to create one for them. This is relatively easy to do and just needs a little space.

Marija Mussorina

On the top image we can see that Marija had a whole theatre to use, so she shot from waist height and out into the seating area to add colour.

In the middle image Matthias has cleverly used a mirror, placed intentionally so he could also include the ocean within his composition.

Matthias Richter

In the bottom image Eugene has used a vacant room and asked the couple to dance in a very exaggerated manner. The groom has taken this advice and really dipped the bride in the dance. You can see the bodies and legs of some guests in the background.

Eugene Alexandrov

Charlotte Geary

Fish-eye lenses are hard to master and should be used sparingly - and then only when it really works, as in this image. Charlotte has chosen a low angle to really emphasise the guests in attendance looking from above at the bride and groom.

In the central image the wedding was celebrated on a ship. Andrey walked everywhere looking for the best places to make an interesting photo and found a room with three big windows located symmetrically, with reflections of these windows on a wooden floor. Andrey then asked the newlyweds to stand face-to-face near the central window, looking into each other's eyes and saying lovely words to each other.

Andrey Demotchenko

You can create images like the one on the bottom of this page by placing an off-camera flash or video light behind the couple and shooting into it. Getting your exposure correct is crucial as you want to be able to just see the outline of the couple's faces.

Hollie Marie

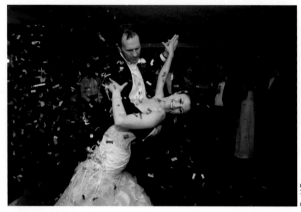

David Pearce

Sometimes everything comes together in an image. The DJ told me he had some confetti which would be "fired" onto the bride and groom. Armed with this information I got into a position just beside the DJ and took this just as the couple "dipped" with perfect timing. Being dancers they performed the dip most elegantly.

DQ Studios

You can really play during the dancing shots. Try putting the camera above your head, as D&Q have here, and shooting down on the action.

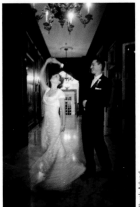

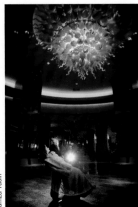

Chuck Arlund

Humza Yasin

Here Chuck has used a slow shutter speed to give motion blur to the bride's beautiful dress. The groom is holding the bride's hand very elegantly.

By shooting wide and in portrait format, Humza has been able to include the gorgeous ceiling light - enhancing the image.

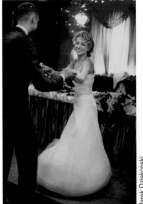

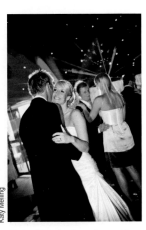

Marek Dziekonski

Katy Meling

Here Marek has used the banqueting room to incorporate the blue tone. A slow shutter speed has added motion blur to the dress but kept the bride's face sharp.

If the disco has laser beams these can be captured relatively easily and really add a splash of colour.

Ela I Michal Barteczko

Barteczko really explores his artistic side when shooting post-wedding sessions. Here he took the couple out into the desert with prints of a zebra and lion creating an illusion that one was hunting the other. The groom is on his knees to indicate that he has been captured.

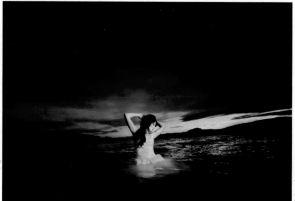

Unique Images

Trash the Dress sessions have proved to be very popular over the past few years. Water is a popular location but be careful that you have protective housing for your camera. Mark has created an image taken moments before darkness, to look like a midnight session. He has lit the bride with flash to ensure she really stands out. The stars finish the image perfectly.

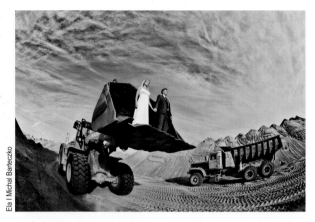

Ela I Michal Barteczko

It is worth extra effort to create masterful images that will separate you from your competition and make you stand out. Here Barteczko got permission to visit a sand mine at dawn to create an image that represents a metaphor of marriage as an everlasting building site. Please remember to observe all Health & Safety regulations when attempting images such as this!

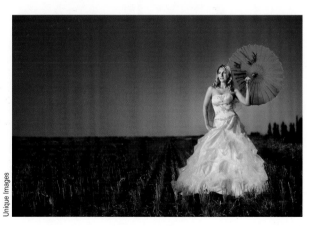

Unique Images

Our cover image. Just take in the colours. From the greens to the deep blue sky and finished by the red umbrella. The dress has been lit exquisitely from the side and the use of flash has really brought out the greens.

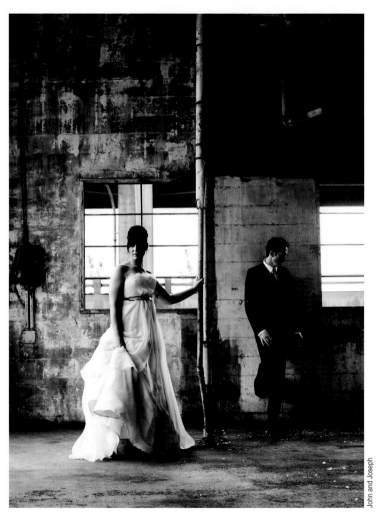

John and Joseph

There is a lot happening within this image. The bride is holding her dress up, giving her something to do with her spare hand whilst looking past the camera. She is angled at 45° from the camera but looking down the line of her shoulder. The groom is facing in the other direction, with a leg against the wall and a hand on his thigh.

I just love this image of the bride and could look at it for hours. Where is she, what is she doing? The expression is fantastic and to my mind the composition is perfect. It is a haunting image. Beautiful.

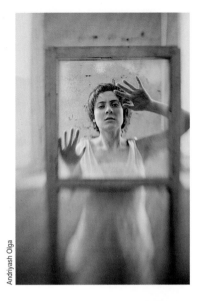

Andriyash Olga

And perhaps the opposite to the above is this image, which is all about the romance. This was shot with a shallow depth of field through the long grass. Notice how delicate the image is, their hand positions and her expression (looking down and with eyes closed). Doing a romantic session after the wedding is a good idea if the couple have been unfortunate with the weather on the day and endured rain.

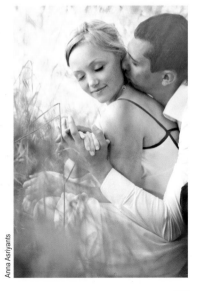

Anna Asriyants

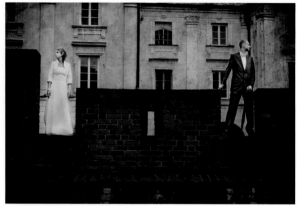

Marek Dziekonski

Both the bride and groom look in different directions and out of the frame - which is unusual - but when you understand the rules you can break them. The groom is posed in a dramatic fashion with one hand on the wall and the other holding an umbrella.

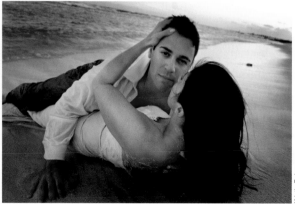

Kristin Reimer

Couples love beach shots so take the opportunity to take them. Kristen has got down low, bringing impact to the shot. They are placed in the shallows of the surf and have been asked to embrace. Kristen has then called to the groom who has looked up at her.

Ela I Michal Barteczko

This session was taken in Borne Sulinowo: a town in Poland which was a Soviet military base from 1945-1992. Most traces of the past Soviet splendour have disappeared but Barteczko managed to find an interesting mosaic preserved on a wall. It showed people in colourful folk clothes, and his couple joined them merrily in dance, playing at Soviet country dancers. The lesson is to look for pieces of art or sculpture and to copy them within an image.

Steve Zdawczynski

Talk to your couple and find out their interests. If you can base a shoot around these then try to do so, This shot is all about the strobe. The sun is backlighting and acting as a hair light. Two speed lights are on full power and off-camera to light the bride

247

Olga has asked the bride to stand on top of the stairs and throw her two veils into the air, then to bring her arms down creating this shape. It may take a lot of goes to get right.

Andriyash Olga

Ela I Michal Barteczko

This image accompanies Barteczco's previous one of the lion and zebra. They are from a series called "Fauna on the Wedding Aisle". He is telling a story of enamoured animals in this shot.

What a great idea this is if you have a couple confident to do it. How romantic for newlyweds to sit in a busy street and have a busker perform for them. I actually like this idea for the wedding day as opposed to a big reception.

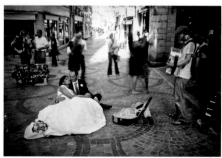

Kevin Tran

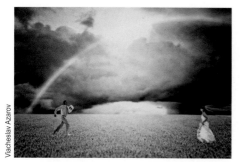

Viacheslav Azarov

The timing here is perfect – stormy skies and a rainbow which contains the couple. The photographer has asked the bride to lift her dress to give her something to do with her hands. The groom was no doubt asked to do an exaggerated run, to good effect.

You may recognise this as the location used in The Da Vinci Code outside the Louvre in Paris. Kevin has created depth in this image by shooting at an angle through the pyramids. Their lines and shape make this a very dramatic image.

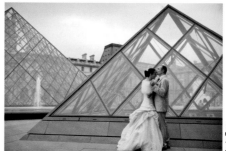

Kevin Tran

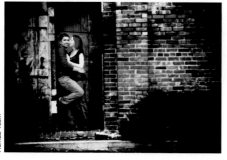

Humza Yasin

The lady is leaning into her fiancé with her hand on his chest. She kisses him on the cheek whilst he looks to the camera and has his knee bent. Negative space has been used effectively.

Steve Zdawczynski

Post-wedding sessions give the bride an opportunity to put on her dress again and go to locations at the wedding venue she may not have been to on the wedding day. This is a standard shot with its leading lines, but always well-received by the bride and groom.

Kristin Reimer

I really like the way the bride is holding and framing the groom's head in this shot, whilst looking in the other direction.

Marek Dziekonski

Clearly do not do this in European countries with live rail tracks! Otherwise have fun and be careful. This is another perfect example that clearly demonstrates you do not need to include the couple's faces.

Sybrand Cillie

This is all about the timing. You have to be pretty precise, get to the location in advance, and be warmed-up first. It is hard to go into a session and create shots like this so plan ahead and make this the final shot. A perfect finish to a session.

DQ APPROACH: PEOPLE. ART. LOVE.

Dave and Quin are two of my favourite people and I thought it fitting to finish this book with some words by them giving an insight into their approach. See their website at www.dqstudios.com for information on their excellent workshops and products.

For Quin and me, wedding photography is about much more than photography or business; it's a passion for people, art and love.

Passion for Marriages - First and foremost, we're self-professed hopeless romantics. We've been married for over 11 years and feel truly blessed to work together each and every day. Yes: we're "that" couple who love to be together every moment of every day, holding hands while experiencing all life has to offer us. Our hope in being wedding photographers is to inspire and remind our clients, through relationship and imagery, of how deeply they love and of their promises made. It may sound altruistic or even "cheesy," but our highest goal is this: to save just one of our couples from an argument, or better yet, save their marriage.

DQ Style - Artists reveal a part of themselves in their creations, and in photography we shoot out of who we are. Being a husband and wife team, we have the good fortune of being able to combine the best of two very different worlds to create a body of work far more powerful than the sum of its parts. Quin's tendency is for the fashion-forward, stylish yet elegantly beautiful. This is equally matched with a rare ability to capture true and sometimes quirky moments. Her beautiful smile, quiet confidence and command of her craft set those around her at ease. All of these elements contribute to a unique revealing of character for those finding themselves in front of her lens. As for me, I love to push myself technically in both shooting and lighting. I'm "Mr. Never-Enough", opting instead to push past what I did last week to move beyond the expected and ordinary. My loud and easy laugh and desire to please balance out our team effort.

Together we create dramatic, powerful imagery that blurs the lines between "captured or posed" and "ambient or flash." Definitions are meaningless and we prefer to use our synergy to be misfits of the medium we call photography, bringing all our God-given talents, skills and resources to every shoot.

DQ on Growing your Business - It was never our intention to create a high-grossing wedding photography business. In fact, if you told me 10 years ago that I would have a career in wedding photography, I would have laughed and called you crazy! Even crazier: profitability was a by-product of our commitment to uncommon quality, client service and presentation.

Quality - When we first opened our doors, we developed and printed our own black

and white film and loved having control of the entire creative process from shoot to print. When we went digital years later, we decided to keep our commitment to quality and chose to fully retouch every image we delivered. We had no idea what we were getting ourselves into! Our post-wedding workload was titanic, but having every image a "wow" image had many benefits, including happy clients and an unmatched body of work.

Client experience - From the start we purposely aimed to create a great client experience. Our goal was, and still remains, to surpass expectation at every point of contact. This includes the first email, the actual shoot, and extends beyond the delivery of the album. Providing uncompromising service and unexpected connection is another contributor to our success as a business.

Presentation - The final piece of the puzzle lies in our creation of methods and products to best help our clients share their story. Why hire a professional to capture the wedding if there's nothing to share for generations to come? Being an advocate for our clients and helping them create the perfect vehicle to share their day is one of our primary goals. Achieving it creates the triple-win of ecstatic clients, greater awareness of the power and impact of our work, and profitability.

DQ Focus - People. Art. Love. Great client experiences, the pursuit of excellence in photography, and a true passion to help our couples succeed in marriage and in sharing their story. This is the perfect, organic breeding ground for creating a successful wedding photography business.

DWF

The DWF is an amazing community that began as film photographers were trying to figure out how to shoot professionally with these crazy little digital cameras. Over the past ten years it has grown into the most active, most vibrant, professional photography website in the world.

Thousands of wedding and portrait pros check in every day at the DWF, and catch the latest trends, business techniques, and education. The discussions amongst 5,000 pro photographers serve as an amazing resource - you can literally ask a question online and have valuable, detailed answers on your screen within 20 minutes.

But the DWF is more than a resource: over the course of time countless friendships have been struck, members share wedding shoots, trade gear, start studios together, even marry each other.

I urge you, if you're serious about weddings or portraiture, to visit the Digital Wedding Forum at www.digitalweddingforum.com. They offer trial memberships free of charge. Take a membership: it could change your career, or even your life!

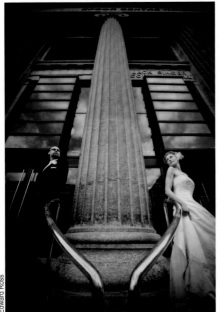

Edward Ross

I invited DWF members to submit images into a contest, with the winner's image appearing in this book. This is the winning image that I chose, by Edward Ross. I loved the symmetry of the railings, the imposing column in the centre and the bride and groom looking round it to one another.

CONTRIBUTORS DETAILS

Adrian Downing – www.kensaphotography.co.uk
Alexandr Arkhangorodskiy - www.arkhangorodskiy.ru
Alexey Antanenko – www.antaneko.com
Andrey Amirhanian - www.sv-21.ru
Andrey Demotchenko - http://demotchenko.com
Andriyash Olga – olga-andriash.com
Anna Asriyants - www.annaasriyants.com
Brendan Landy - www.landyphoto.com
Charlotte Geary – www.charlottegeary.com
Chenin Boutwell – www.boutwellstudio.com
Chuck Arlund - www.chuckarlund.com
David Beckstead - www.davidbeckstead.com
Desi Baytan – www.desibaytan.com
DQ Studios – www.dqstudios.com
Du Wayne Denton – www.duwayne.co.za
Ela I Michal Barteczko – www.barteczko.pl
Elena Bocharnikova – www.elenstudiophotography.com
Emma Hughes – www.weddingsonwaiheke.co.nz
Eugene Alexandrov – www.artephotography.book.fr
Heather Zawalick - www.heatherzphotography.com
Hollie Marie – www.holliemariephotography.com
Humza Yasin – www.humzayasin.com
iMAG1NE - www.imag1ne.com
IMMI - www.immi-photography.com
Jake Morrow - www.studiojblog.com
Jean-Pierre Uys – www.jeanpierrephotography.co.za
Joanne Dunn – www.joannedunn.it
John and Joseph – www.johnandjoseph.com
John Michael Cooper – www.altf.com
Jose Del Valle - www.josedelvallephotographer.com
Karen Bridges – http://weddings.beyondthewell.com
Katy Melling – www.katymelling.com
Kerry Morgan – www.kerrymorgan.com
Kevin Tran – www.kevintran.fr
Kris McElligott - www.kmphotographyweddings.com
Kristin Reimer - www.photomuse.com
Kudegraphy – www.kudegraphy.com
Leslie Gilbert - www.lesliegilbertphotography.com
Marek Dziekonski - www.marekd.com
Marija Mussorina - www.mafka.com
Mario Sales – www.mariophoto.co.za
Matt Pereira - www.mattpereira.co.uk
Matthias Richter - www.matthiasrichter.de
Michael O'Neil - www.michaeloneillfineart.com
Nathan Bridges - http://weddings.beyondthewell.com
Nikki McLeod – www.nikkimcleodphotography.com
Noel Del Pilar – www.noeldelpilar.com
Olga Aleluhina – www.aleluhina.com
Philip Andrukhovich – www. fotograni.ru
Romeo Alberti – www.fotografromeo.ru
Russ Pullen - http://www.level-eleven.com.au/
Scott Robert Lim – www.scottrobertgallery.com
Steve Zdawczynski - www.stevezphotography.com
Sybrand Cillie – www.sybrand.co.za
Tasha Herrgott - www.redbirdhills.com
Timothy Pham – www.studiopham.com
Tsutomu Fujita - www.boztsutomu.net/wedding
Unique Images – www.uniqueimagesphotography.ca
Viacheslav Azarov – www.exestudio.ru
William G – www.mwpstudio.com
Yervant – www.yervant.com

OTHER PUBLICATIONS

In this book Kerry Morgan details how she captures stunning, world class images and what you can do to transform your work. A comprehensive guide to wedding photojournalism giving you the tools you need to capture beautiful story-telling images that will 'wow' your clients.

Wedding Photography
A Guide To Photojournalism

The Invest In Knowledge Series

By Kerry Morgan

OLIVERCAMERON
PUBLISHING